Just Draw

Botanicals

© 2020 Quarto Publishing plc.

First published in 2020 by White Lion Publishing,
an imprint of The Quarto Group.
The Old Brewery, 6 Blundell Street,
London, N7 9BH,
United Kingdom
T (0)20 7700 6700
www.QuartoKnows.com

A catalogue record for this book is available from the British Library.

ISBN 978-0-7112-5132-8

10 9 8 7 6 5 4 3 2 1

This book was conceived, designed and produced by
The Bright Press, an imprint of the Quarto Group

Publisher: Mark Searle
Creative Director: James Evans
Managing Editor: Isheeta Mustafi and Jacqui Sayers
Commissioning Editor: Sorrel Wood
Editors: Jo Turner and Abbie Sharman
Design: Ian T. Miller

Printed in China

Cover Images (left to right, top to bottom):

Front:
Giacomo Bagnara, Helen Ström,
Chris Meechan, Mary-Clare Cornwallis,
Marie Burke, Henrik Simonsen,
Gabby Malpas, Helen Gotlib

Back:
Hennie Haworth, Rachel Lockridge,
Helen Gotlib, Annie Patterson, Kathy
Pickles, Michelle Li Bothe, Claire Pelta

Just Draw
Botanicals
BEAUTIFUL BOTANICAL ART, CONTEMPORARY ARTISTS, MODERN MATERIALS

HELEN BIRCH

Contents

Right: *Primula Silver
Lace*, Laura Silburn

Flipping through this book

In addition to the contents listing opposite, we have included artist and visual indexes to help you dip in and out of this book. Use these to find specific information or paintings quickly.

Visual index

Because this book is as much about visual inspiration as it is about technique, we have included a visual index on **pages 6–9**. If you are trying to find an image you have already seen in the book, or you are looking for a specific style, colour or background, use this to take you straight to the correct page. Page numbers are included on the thumbnail of each illustration.

Artist index

If you would prefer to search for images via the artists, an index listing artists alphabetically by last name is on **pages 204–205**. Here you will find a full list of the pages on which their art appears and also blog or website details, if you would like to check out more of their work.

Above: *Side of the Path*,
Hennie Haworth

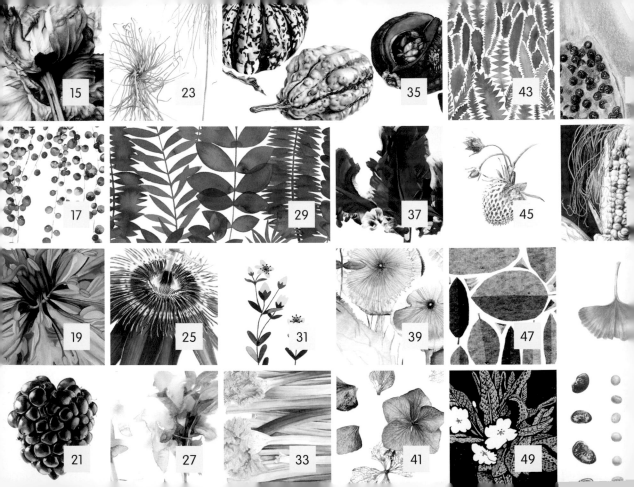

59

65

73

81

89

97

67

75

83

91

99

61

69

77

85

93

101

63

71

79

87

95

103

Why botanical?

This book takes a broad look at botanical works – many are watercolour based, as this is the traditional medium used to depict flora. The book also includes some fine art and new media approaches.

The art of botanical drawing and painting arose centuries ago from the need to record and retain knowledge about the plant kingdom – a source of food, medicine and wonderment. Botanists still need high-quality illustrations for their scientific publications, and there is a demand for, and renewed interest in, botanical art, too.

Botanical illustration, botanical art and art with a botanical theme have fundamental differences, but what they have in common is looking to the plant kingdom for their inspiration. Botanical illustration provides clear information about a plant specimen for botanists – these works are most often monochrome. Botanical art makes up the majority of works in this book; it is scientifically and botanically correct but places a much greater emphasis on aesthetic value and is more likely to be rendered in colour on a plain background. Finally, flower paintings, or works with a botanical theme, tend to explore wider concepts and ideas – still life, context, impressions, perception, metaphor and the like.

The plants you see in this book have been observed in humble and exotic places alike – some found on specific research trips, many grown in the artists' own gardens. In choosing botanicals you will never run out of subject matter. Estimates for the actual number of plant species range from 350,000 to in excess of 1,000,000.

All of the artists represented in this book have chosen botanical subjects that mean something to them, and worked with materials that intrigue and challenge. Many have retrained in botanical work after very different careers; some are designers who specialise in floral themes; others are new graduates from art school, have won prizes for their art, or undertake botanical study for meditative well-being. Their work has been selected to inspire you to make botanical art too.

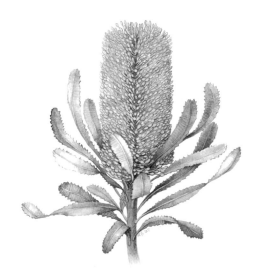

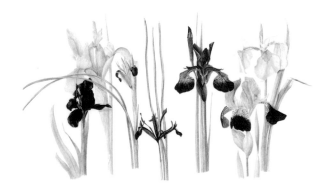

Above: *Banksia Aemula*, Robyn Graham
Left: *Iris Family*, Jan van der Kamp

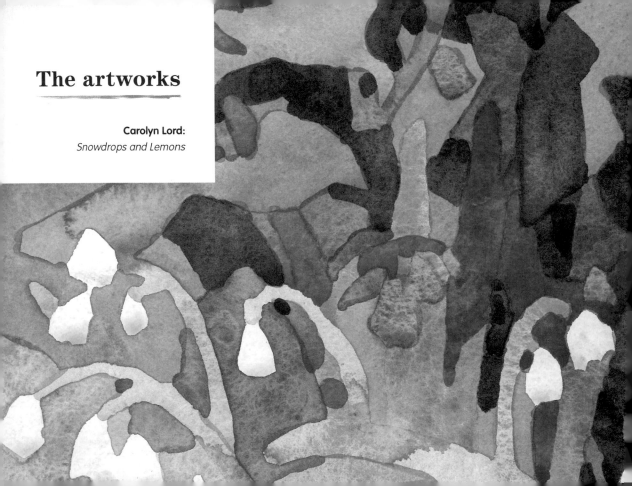

The artworks

Carolyn Lord:
Snowdrops and Lemons

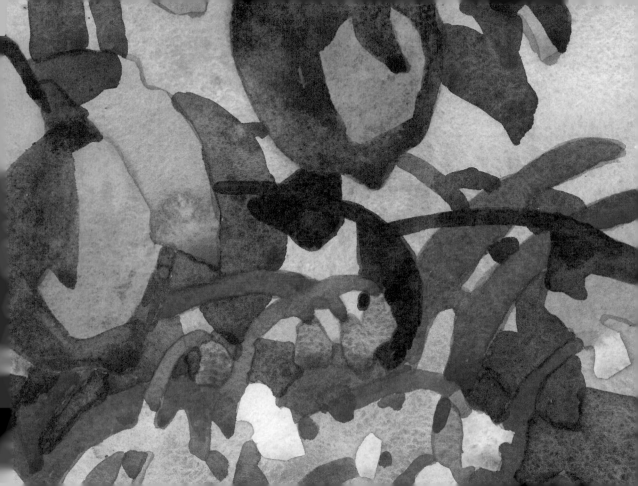

Close-cropped drama

Marie Burke

An ageing beauty, the bloom in Burke's *Peony* watercolour is just past its best. See how she captures the changing shapes of the petals curling over as they dry out, rendering them in hues that typically become richer and deeper just before the flower turns brown.

Before progressing to botanical painting, Burke was an artist-blacksmith specialising in forged steel sculpture. She remains drawn to sculptural forms in nature, as here, in the dramatic shapes arising from the drying-out and shrivelling-up process. The effect is impressive and flamboyant – characteristics exaggerated by the close-cropped manner in which Burke has painted the peony.

Tip It's easy to crop without resorting to either scissors or mount board. Use photo-editing to try different crops without touching your original.

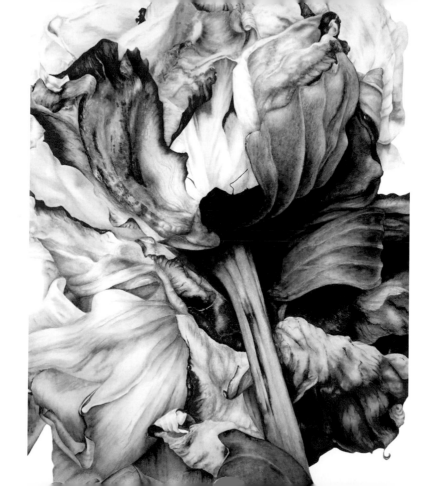

15

Inspiration and rhythm

Trina Esquivelzeta

With a habit of sprawling over the edges of its growing container, the string of pearls is a popular houseplant. The foliage looks just as its name suggests – round, fleshy, pea-like leaves are attached along slender stems. In *Pearl Plant Print*, Esquivelzeta uses a combination of watercolour painting and digital manipulation to produce the plant's multiple 'pearls'.

Esquivelzeta's technique is simple, but effective. First, she painted the individual strings and some of the leaves using watercolour washes of green and blue. She then scanned and overlaid several versions of the work in Photoshop to give the effect of multiple overhanging strings.

Tip Scanning and digitally manipulating your work offers great scope for experimentation. Digitising your work also enables you to record different stages of progress and to keep a digital file of a finished piece.

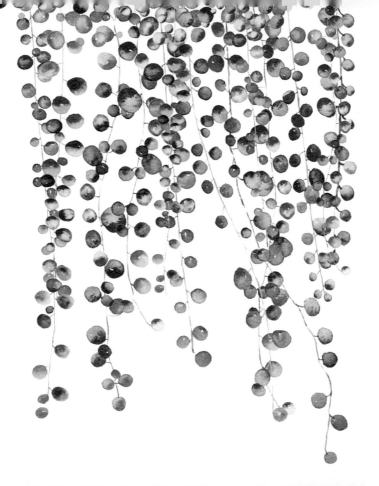

High-key colour

Claire Pelta

Pelta has chosen to use a predominantly high-key palette for her azure-blue-on-white oil painting, *Nigella*. Meticulous in detail on a larger-than-life scale, this piece is characteristic of Pelta's work. Drawing on nature's colours, from pale and delicate to bold and strong, the artist creates paintings that are both sensitive and dramatic.

'High key' means pushing the values of a painting towards the lighter end of the value scale. In order to do this, it is important to understand tone. For example, in this painting, the deep-green centre of Pelta's Nigella flower creates a tonal counterpoint in amongst the pale blues and mauves of its petals.

Tip Try squinting at your subject. Doing so reduces mid-tones, leaving you with darks and lights. Once you've established the tonal values in your subject, you can decide whether to go high or low key with your work.

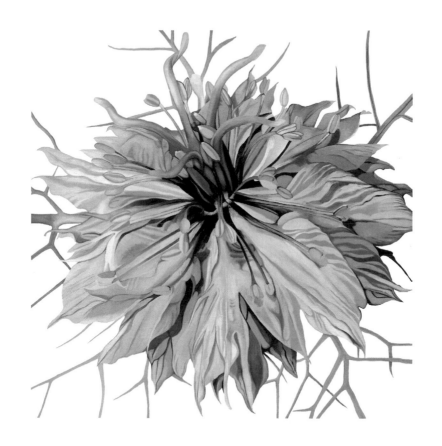

Overlaying washes

Victoria Braithwaite

Braithwaite's painting of a blackberry – the fruit of the bramble – is remarkable for its apparent realism; the luscious, shiny surface looks convincingly like that of the actual fruit.

Illusion like this is achieved by understanding the tones of the object you are observing – the range of lights and darks, from highlight to shadow. You can then build the colour gradually in layers, using increasingly darker tones. This overlaying of transparent watercolour washes is known as glazing. In *Bramble*, Braithwaite used a dry brush to add details once the layers of wash were complete.

Tip It's important to allow each layer to dry before applying the next. You can use this drying time as an opportunity to step back from your work, make a tonal assessment and darken things where needed.

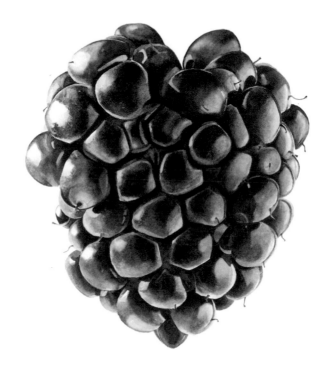

Unique characteristics

<div align="right">

Carol Ashton-Hergenhan

</div>

Ashton-Hergenhan has painted an aptly named cultivar *Allium sphaerocephalon* 'Hair', a spidery looking mutation of a drumstick allium. Leaving ample white space surrounding each flower helps the specimens to remain light and fluid, and for their characteristic 'hair' to be clearly seen.

These plants are not orderly, which makes them hard to represent. Ashton-Hergenhan used basic watercolour techniques to paint them, but with multiple colours loaded onto the brush to create multi-hued strokes. She paid particular attention to overlaps, which helped the flowers remain coherent.

Tip As well as arranging plants to create 'dialogue', you might also choose to paint or draw a single object because of its 'character' – Asuka Hishiki's *Giant Kohlrabi* on page 133 is a good example.

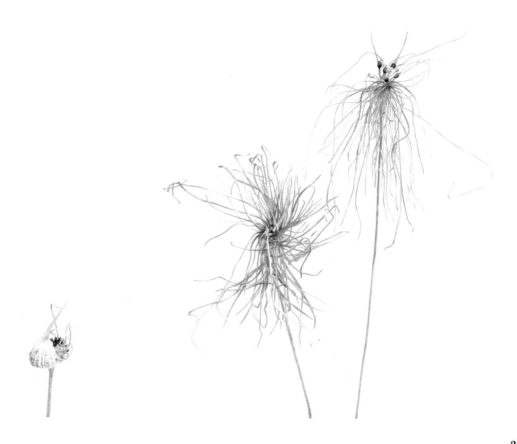

Identical details

Denise Ramsay

Ramsay's undertaking to paint truly remarkable flowers is realised in *Flight of Passion*, one of a series of paintings exploring flowers that are sculptural and alien-like in their appearance.

Quite often, the challenge of botanical drawing lies in painting multiple identical details, as here with the passionflower's blue coronal filaments. Ramsay chose to paint just a small group of filaments at a time so that she could intersperse them with painting other, more dramatic sections of the flower, such as the stamens.

Tip If you choose an ambitious project, make sure that you are able to sustain your focus. If you alternate repetitive and laborious elements with more fun and spontaneous sections of a work, the end results are likely to look fresher and more alive.

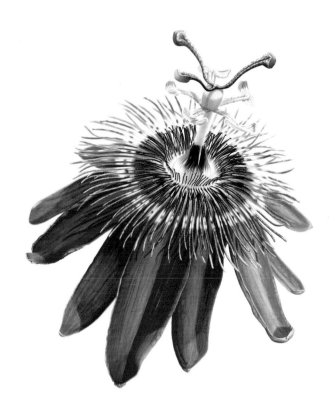

Sketching with paint

Helen Ström

A bunch of mint sitting in a container of water is a common enough sight in many kitchens. In Ström's *Mint Study in Watercolour*, much is suggested using a few watery paint strokes, while one side of the glass jar isn't painted at all.

Ström completed this watercolour swiftly and without sketching guidelines before painting. She has trained herself to be spontaneous with her brushwork, trusting that the result will follow. Her technique is to make multiple reworkings, wet on wet, and to use a brush loaded with clean water to dilute colour on the paper surface to correct 'mistakes' – a technique known as lifting.

Tip Such confidence in one's own ability comes from lots of 'real looking', and plenty of practice. Using a robust, cold-pressed paper with a textured surface makes wet-on-wet and lifting techniques easier to achieve.

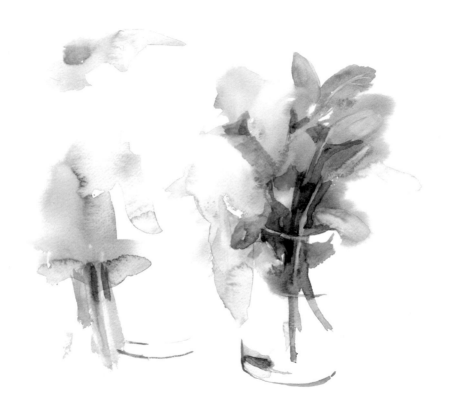

Granulation

Natalie Ryan

Ryan's *Indigo Garden* depicts multiple leaf shapes rendered in a single colour. Sourced from the artist's rambling farmhouse garden, she used the plants to explore wet-on-wet watercolour techniques.

In particular, Ryan explored the granulating effects of different shades of dark blue, primarily indigo. Granulation is the reaction of certain pigments to water. It's a phenomenon most apparent in wet-on-wet work. In this piece, the shifts in just one colour – leaves darker at the edges, blooms and back-runs in some places and not others – are all due to this effect.

Tip Granulation can be used to great effect on textured watercolour paper. As the pigment breaks away from the binder it settles into the valleys of the paper, leaving a grainy texture. Tilting the paper slightly whilst the paint is wet can help accentuate the characteristics of granulation.

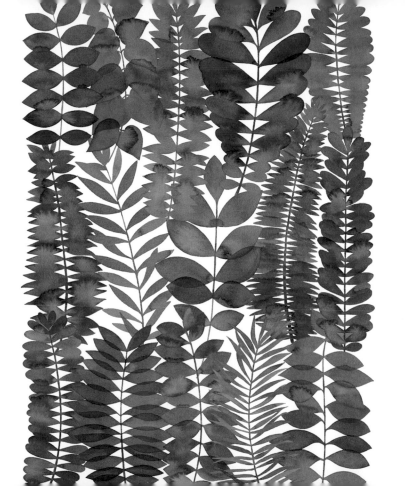

29

Editorial illustration

Valesca van Waveren

This illustration, *St John's Wort*, was one of eleven herb illustrations that also included dandelion, elderberry and nettle, amongst others. They were created to complement a written article.

Editorial illustration differs from scientific botanical study; allowing for poetic licence, it is less about absolute accuracy and more about capturing the idea of a plant. It is also important to maintain a visual unity across the series. In this example, the eleven illustrations utilised a simplified colour scheme: each was completed using a greyish-black and one other colour. Here, the stamens of the flowers have been drawn in using a fineliner pen.

Tip When producing illustrations for printed editorial use, it is common to scan the finished image and tidy it up in Photoshop – whites are brightened, edges cleaned up and any accidental drips and splodges removed.

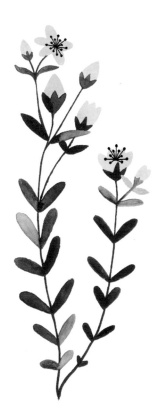

Arranging specimens

Victoria Braithwaite

Braithwaite's *Forced Rhubarb* captures perfectly the complementary colours and contrasting patterns and textures of this tart spring vegetable. The strikingly real appearance of the rhubarb has been achieved through the glazing technique also used by the artist in *Bramble* (see page 20).

Of particular note in this work is Braithwaite's composition, for the art of collecting and arranging botanicals is about how best to illustrate their characteristics and personalities, as well as how to represent them accurately. Here, Braithwaite arranged the rhubarb stalks in such a way that they created broad, horizontal pink stripes – sometimes running in the opposite direction. She then topped the stalks with pale yellow-green leaf frills. This fresh, light-hearted and informal arrangement has a lightness of touch that the layering of washes helps to maintain.

Tip Before you start a botanical study, consider looking at your specimen from different angles and in new ways – for example, lying horizontally, sitting vertically in water, scattered on a tabletop, in situ, foreshortened, arranged formally and in colour groupings.

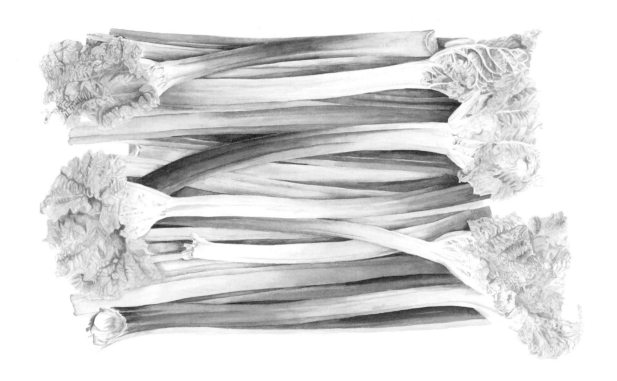

Botanical illustration

Clare McGhee

In *3 Squashes*, McGhee captures the vegetables' colourful markings, gnarly surfaces and wonderfully sculptural shapes. Cutting into one of the squashes to expose the orange flesh and its seed hollow adds to the set-up.

McGhee studied to be a botanical illustrator. This painting is one of several watercolour vegetable studies from her student portfolio. She applied tonal underpainting to provide a solid foundation on which to build up a series of washes. She then used blending techniques to capture both colour and form more accurately, demonstrating a good eye for supercharged detail.

Tip Works like this win competitions because they combine scientific accuracy – depicting form, colour and detail that identify a specimen – with visual appeal. When painting fruits and vegetables, consider cutting a piece in some way to expose the flesh and texture within.

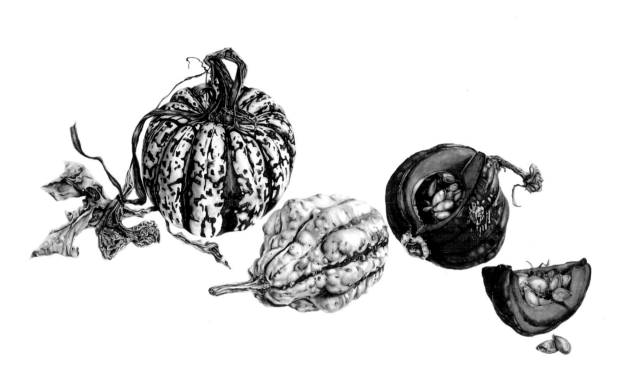

Rendering reds

Madeline Harper

Red Parrot Tulip 'Rococo' reveals much of its character in its name: the ruffled, feathered petals resemble the wings of a parrot, and rococo – an exuberantly theatrical decorative style. Harper celebrates these characteristics in painting a flower grown in her own garden.

That red demanded attention. It's a heightened colour. Harper hasn't only worked from life; she also referenced a photograph. Camera-captured reds appear super-saturated, not quite true to life. In this instance, the decision to use a photograph has added to the tulip's dramatic appearance. Key to this study is having the right red. Even though it is a primary colour, red can be cool or warm. A warm red will make wonderful oranges; a cool red will create better purples.

Tip Create colour swatches and colour charts for yourself. Manufacturers' paints vary widely in terms of their pigment content, names, characteristics, fastness, staining qualities and cost. A record of what you've discovered as you've gone along is an invaluable resource.

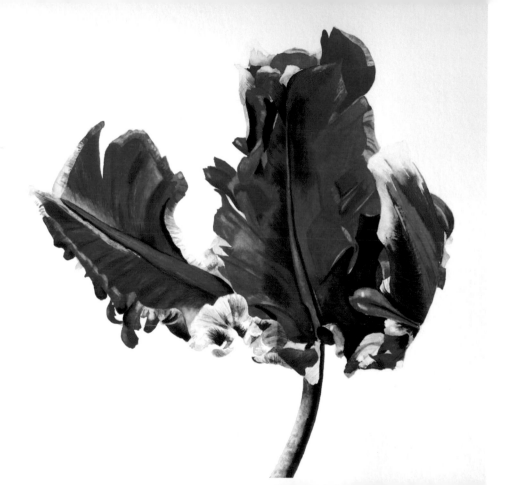

Wet on wet

Amber Alexander

Owing much to the properties of watercolour as a looser medium, *Mushrooms and Maidenhair* is an interpretation of fungi and ferns rather than an adhered-to observation.

Large pools of wet on wet make up both the lower portion of the work and the mushroom caps. Into this, Alexander has flooded a cooler blue-green, creating back-runs. The result suggests a mossy environment. When the washes were dry, Alexander was able to add detail with a fine brush: fern fronds, mushroom gills and spores, and red moss stalks.

Alexander was inspired by the lushness and softness of spring and summer to produce a palette of yellow-greens through deeper sap greens, with added hints of red. Utilising complementary or opposite colours from the colour wheel adds a counterpoint to this lush, washy image.

Tip Like Alexander, always try to mix your own colours – they will seem more natural. If you want a texture or uneven wash, mixed colours often partially separate on the paper – known as granulation. Using cerulean and ultramarine blues, raw sienna, burnt sienna and burnt umber will enhance this effect the most.

39

Constituent parts

Carolyn Jenkins

In *Hydrangea Macrophylla*, Jenkins shows the various stages of this multiple flower head's ageing. A healthy single blue flower lies at the centre of the work and is surrounded by others, plus their petals, all at different stages of decomposition. This careful study was part of a series for a Royal Horticultural Society botanical painting exhibition.

By deconstructing the mophead hydrangea's multiple flower head into its constituent parts, Jenkins helps us to understand some of the complexity of the individual elements that make up the flower's dramatic blooms. It is a clever idea that allows Jenkins to go a step further to include the hydrangea's petal skeleton. Left on the plant, the flower heads gradually change colour, fading to brown and drying to reveal their structure – Jenkins' painting shows those stages, beautifully arranged.

Tip Hydrangeas dry beautifully. This means that they can be used as plant studies you intend to take some time over. By drying, they have stabilised – no watering necessary, and no wilting! Orange, pink and blue flowers tend to retain their colour the best.

Shape and colour

Natalie Ryan

Ryan is known for producing hand-painted designs and artworks influenced by Australia's flora and fauna. This piece, *Banksia Leaves*, depicts several varieties of the Banksia plant that grows predominantly in southwest Australia.

The emphasis here is on shape and colour. Ryan has used her botanical knowledge to arrange the leaves in such a way that the leaves fit snugly, with few gaps between them. Their toothed edges tessellate here and there. Everything is kept monochrome and the distinctive shapes of the leaf silhouettes are so wonderfully formed that only a stem is needed to define them any further.

Tip The monochrome green colour scheme, with its many subtle variations, does not rely on ready-mixed green. It utilises a palette of subtle colour mixing and variegated washes.

'Unpainted' highlights

Clare McGhee

Measuring 20 x 20 cm, *White Strawberry* is approximately twice the size of the reproduction in this book. Even at a reduced size, it's easy to see how detailed a study it is of this distinctive, naturally white fruit with its red seeds.

Deciding what not to paint was an important consideration for McGhee. In leaving areas unpainted, she has allowed the white of the paper to become a highlight. You can see those points as the reflection on each strawberry pip and the glistening, shiny areas of the fruit's surface.

Tip The strategy for a successful watercolour is to plan your work – especially if your subject is as complex as this and you are going to rely on unpainted sections of paper to play a role.

45

Textured collage

Giacomo Bagnara

Leaves and Stones is a collaged monochrome study that sees simple leaf forms arranged in a rectangular block. The leaves are juxtaposed with coloured gemstones whose shapes occupy the negative spaces between the leaves.

Bagnara's simplified grey palette is an important element of his collage. He used just two narrowly shifted tones of grey to make up the halves of each leaf. No other details were included, and this allows the shapes and forms of the leaves – often overlooked in favour of flowers – to become the focus. They include cordate (heart-shaped), lanceolate (pointed at both ends), orbicular (circular) and linear (long and thin). The subtle greens and ochres of the gems each utilise three tones.

Tip You can make your own interesting collage papers by scanning, photocopying or photographing and then printing textures. A work like this can be achieved whether you use paper, scissors and glue, or scans and photo-editing software.

47

Sketchbook ideas

Anna Violet

Violet is a children's book illustrator. Her books feature designs of flora and fauna developed from observational drawings. *Primroses* is an observational drawing of a plant growing in her garden.

All good illustrators keep sketchbooks in which drawings can be developed, styled and embellished. Don't necessarily try to get your drawing or painting 'perfect' from the get-go. Preliminary doodles, sketches and 'workings-out' are important. Make it a habit to devote time to less 'finished' work, aiming for an experimental and curious approach. Violet spends a lot of time sketching and researching. She plays around with different inks and a variety of pens and brushes. This particular piece was drawn on cartridge paper using a dip pen. An ink wash and digital finish complete the illustration.

Tip The Magic Wand tool in Photoshop can be used to colour large areas of solid colour – replacing or removing it – such as in the background here. Many tutorials showing you how to do so are available online.

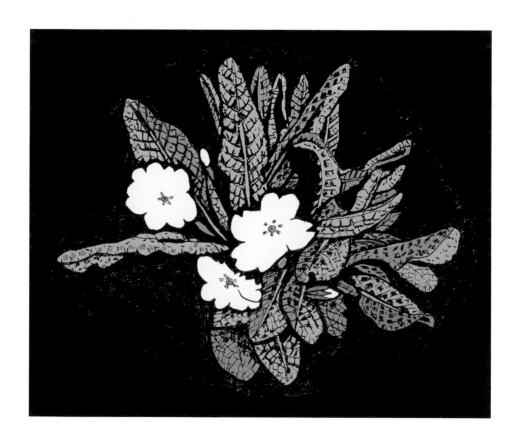

49

Harmonious colours

Sarah Melling

Melling's *Papaya* is a study of the fruit, having been cut in two halves. As in the artist's *Haas Avocado* on page 151, the front and back portions are displayed as comparisons of inside and out.

The work is also an exercise in working with harmonious colours – in this case yellow and orange. Also described as analogous, such colours create compositions that are especially pleasing to the eye. For that reason, the use of black for the seeds is carefully done here, with a shift to olive green describing seeds submerged further within the fruit's pulpy centre.

Tip Black can often deaden a work because it flattens or dominates other colours. Here, it doesn't, largely because the artist has taken care to give each seed its own fleck of reflected light.

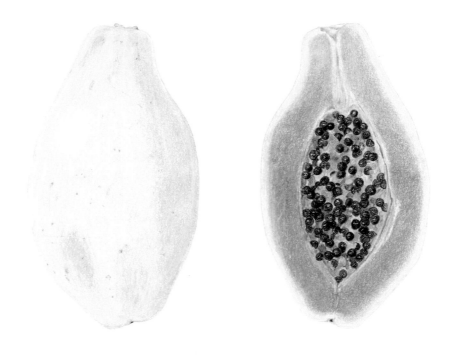

Contrasting elements

Annie Patterson

This unreal-looking ear of Glass Gem corn, grown by the artist from much sought-after seed, is a genuine strain of maize. Patterson's painting *Corn, Glass, Gem* is a celebration of its jewel-coloured, boiled-sweet-like kernels.

The range of colours – and their translucence – make this corn variety an ideal subject for a study in watercolour. To further emphasise the striking colours of these extraordinary multicoloured kernels, Patterson chose to frame them within their textured husk, with its neutral grey stripes, against a blue-black background.

Tip It is unusual to use black in a watercolour painting. Try not to rely on manufactured blacks – they are far too dominant and end up dulling a painting. Mixing your own means that you can vary the colour temperatures – for example, try mixing ultramarine and burnt sienna.

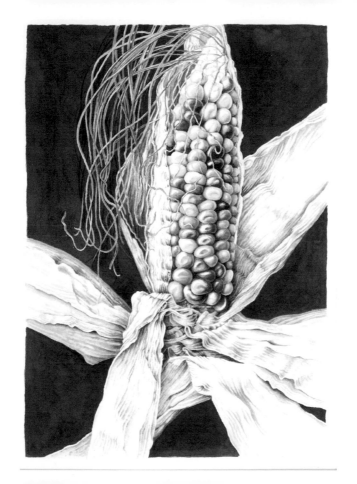

Use of underdrawing

Pond's *Ginkgo Leaf* is a detailed study of a single leaf, centrally placed, and is one of several paintings of leaves found near the artist's home. This particular leaf belongs to the ginkgo or maidenhair tree and the artist's composition invites the viewer to appreciate the primitive characteristics of this ancient *Ginko biloba* species.

The leaf shape is bilobal – essentially a fan shape consisting of two lobes. The green-yellow we see here fades to a mellow yellow come autumn. The careful underdrawing, shifting greens and yellows of the layered washes, and fine brushwork have captured perfectly the unusual shape, curved stem and subtle colour shift of the ginkgo leaf.

Tip Unusual specimens often make inspiring subjects for a detailed study. Local parks may well contain species not commonly seen. Botanical gardens and herbariums certainly will hold many unusual and distinctive species of plant.

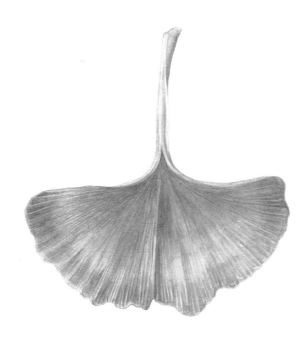

Attention to detail

Asuka Hishiki

Hishiki's *B&B Horizontal Stripes (Beans – Fabaceae)* is all about attention to detail and playing with an idea. Variously these include the illustration's title, its layout and the painting process.

The title has a cryptic reference contained within it. For the artist, B&B stands for 'beans and beetles'. She has arranged the legumes in orderly lines to echo the formal display of a museum entomological (insect) collection. Seen at its true scale (it is reduced here) the beans are painted actual size. A miniature brush was used almost entirely – size 000. The painting consists of many layers of tiny brushstrokes over a minimum of washes.

Tip Herbariums, which are often housed in botanical gardens, arboretums or in natural history museums, are an invaluable resource for seeing the systematic collection and display of plants.

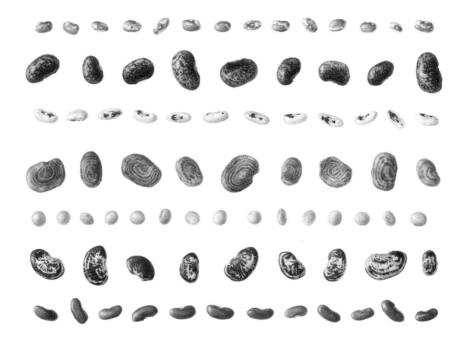

Scientific study

Christina Hart-Davies

Painted life size – the twig is about 7.5 cm long – Hart-Davies' *Lichen: Ramalina Fastigiata* is so accurate that a botanist or other specialist looking at the image in their plant guide would be able to identify the lichen portrayed 'out in the field'.

For Hart-Davies, the whole point of this pencil and watercolour study is its intricate, tiny detail. She first made an outline pencil drawing of the main branches and then carried out a lot of the fine detail using dry brushwork, focusing on the negative spaces and working from light to dark.

Tip Scientific works like this are always drawn and painted from life, never from a photograph. One of the reasons Hart-Davies chose to paint this specimen is because it has the advantage of flourishing in the winter, when there is little else to paint.

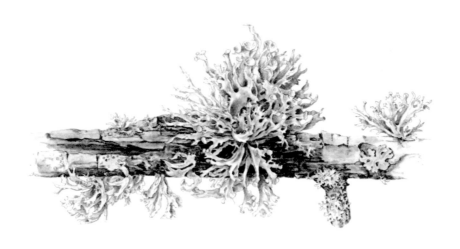

Divided composition

Carolyn Lord

Lord's watercolour *Snowdrops and Lemons* has a strong, vibrant colour palette with cool viridian greens at the front and warmer tones behind. This handling of colour divides the composition – snowdrops in the foreground, lemons nestling in the warmth of the sun in the background.

A southern California native, Lord trained in an area where the California Regionalist Watercolour tradition flourished in the twentieth century. A bold look with strong, rich colours define the tradition. Much of the work was carried out en plein air without any preparatory drawing. In tune with this, Lord worked this piece without pencil, applying block colour initially with a brush and watercolour. She then painted local colour onto dry paper – that is, she added the natural colours of the piece before modifying them with light and shadow. Once this stage was dry, Lord applied a second layer of paint to create the shadow areas.

Tip The 'overexposed' or whiter, washed-out looking band of snowdrops leads the eye to the shadow depths of the lemons. Consider using a camera to experiment with ideas for areas of 'overexposure' in your paintings.

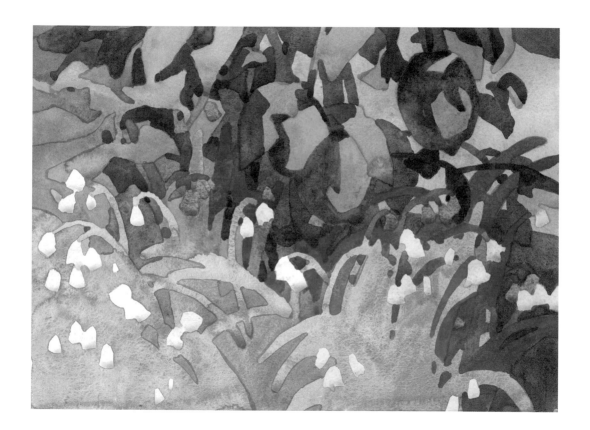

61

Balanced placement

Leigh Ann Gale

Begonias are grown for the shape and colour of their foliage as much as for their flowers. Native to tropical and subtropical areas, their habitat is, in the main, on dappled forest floors. In *Begonia Leaves*, Gale records just three of the many cultivars available, isolated on a white background.

Being a botanical artist, scientific accuracy is important to Gale, but 'artistic appeal' is a factor too. The arrangement of the leaves in this triangular format is a satisfying composition. The eye travels around quite naturally, examining and comparing each leaf. Similarities exist in leaf shape but a shift in colour clearly differentiates each. Gale gives much consideration to her compositions, focusing on the colour balance of the plant components as well as placement.

Tip Use a camera to quickly capture and assess various arrangements and colour combinations, and to help you decide on your chosen composition. Note: work from life – not from the photo you took!

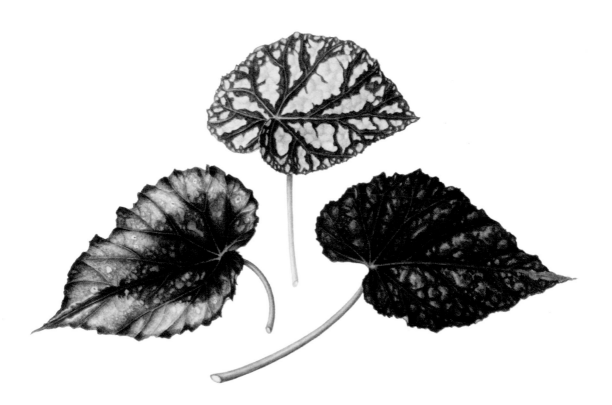

Vivid colour with highlights

Holly Exley

A watercolour enthusiast who has used the medium exclusively since her final year at graduate art school, Exley is passionate about painting food, believing that watercolour is really successful at making food look more delicious than a photo ever could.

Another of Exley's passions is evident in her *Tenderstem Broccoli*: colour. It is her signature style to work in vivid colour with highlights. Key to Exley's success is making sure she has a good light for her subject and understanding how to replicate it so that the work remains vibrant. Typically, she leaves highlights unpainted, or uses masking fluid to pick them out before painting over the top.

Tip Exley is a prolific blogger, often sharing her techniques, processes and new work, including her illustrated recipe book. She also produces a useful series of vlogs aimed at anyone interested in becoming an illustrator.

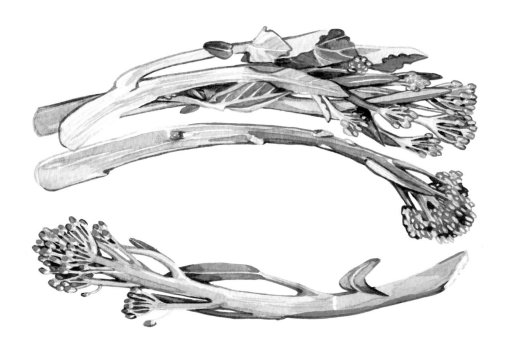

Shape, form and light

Kathy Pickles

Apple Mix by Kathy Pickles is an exemplary botanical study, presenting several species of the fruit in a loose arrangement on a white background.

Botanical studies call for such close scrutiny that sometimes it is difficult to know where to start. Crucial to Pickles piece is her understanding of the ways in which the light falling on the apples helps her to see their basic shapes and so analyse their forms. When light strikes a geometric solid, as here, it creates a set of tones, from highlights to shadows, which allow you to paint more convincingly.

Tip Learning to identify tone is important if you want to achieve solidity in your work. Consider taking a black-and-white photograph of your subject – it can clarify tonal values. Make sure that your light source is a constant one. A static lamp is better than the shifting sun, for example.

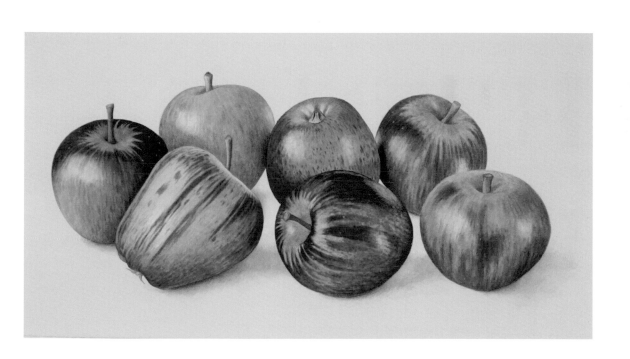

Fine detail

Vicky Mappin

Mustard and Cress is a composition of two halves: a yellow-green for the organic top and a viridian green for the non-organic carton with its geometric zigzags and straight edges.

A plastic cress carton is such an ordinary thing to paint and would be overlooked by many, but this modest green salad deserves a moment of study. Of particular interest in this example is the artist's method of working the fine detail. To begin with, Mappin decided what not to paint. She did not put any paint on the stems of the cress, for example, but worked the colour in between them. Once she had completed the carton, she painted a viridian wash over the stems in the carton.

Tip Miniature or detail brushes with ergonomic triangular handles allow you to paint fine details more steadily; they're also more comfortable for intricate work, allow you to paint for longer and don't roll off the desk when you put them down.

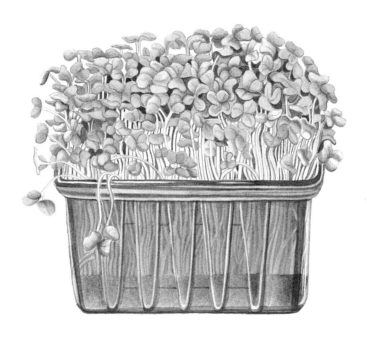

Limited colour palette

Denise Ramsay

The tiger flower only lasts one day. Opening early in the morning and closing at dusk, it has just a few hours of daylight to attract the right pollinators. In *Courtship*, Ramsay has depicted two blooms at their peak, placed diagonally opposite each other on a white background.

Intense in colour, the piece is painted using a limited palette of only three primaries: ultramarine blue, bright red and lemon yellow. Ramsay claims not to have used a tube of green paint in years. She mixed the green for the stalks of her tiger flowers using ultramarine blue and lemon yellow.

Tip It is tempting to use lots of colours in a painting. Limiting your choice not only focuses you to practise your paint-mixing skills, it also helps a painting to feel cohesive.

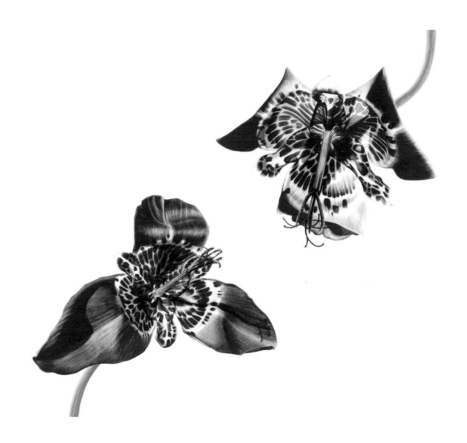

71

Capturing movement

<div align="right">Helen Ström</div>

For this painting, Helen Ström has arranged two specimens of *Maranta leuconeura* in glass pots – vessels she enjoys working with because of their transparency and resulting distortions.

Maranta leuconeura is also called embracing maranta or prayer plant for its habit of raising its leaves into an upright position at night. Ström is drawn to the plant's graphic qualities – the way in which the leaves take angular positions that makes the plant interesting to draw or paint. Her familiarity with the plant has made her confident enough to paint *Maranta* without drawing, in one go, getting an impression on paper as fast as possible. It's a technique that gives the resulting painting a sense of motion, of capturing a moment in time.

Tip To paint specimens in glass containers, you might use long-stemmed florist's tubes – especially if you have a specimen with a longer stem than this, aren't as quick to paint and want to stop your subject from wilting.

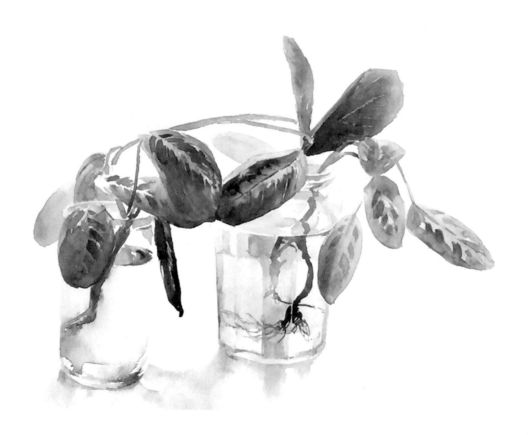

73

Colour influence

Jane LaFazio

Jane LaFazio is a mixed-media artist, fascinated by detail. *Artichoke Family* is a watercolour and coloured pencils piece that was showcased on the cover of the magazine *Edible San Diego*.

Many of LaFazio's watercolours emerge from an art journalling habit of being intrigued and wanting to explore more. The artichokes for this piece were selected for their fantastic shapes and layered petals, and for their colours – green, pink, plum. As an artist, LaFazio seeks to enhance and exaggerate colour. Here, she has used an appropriate pink wash to stain the page, imbuing her painting with an increased sense of warmth.

Tip An art journal or sheet of white paper will seem less intimidating if you stain it first. Be aware, as here, that the stain will 'influence' the painting.

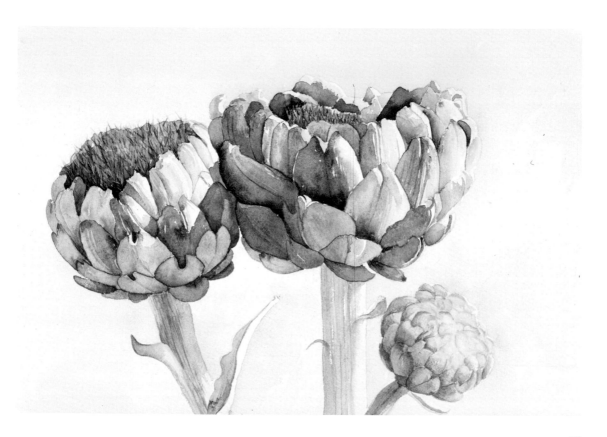

75

Relative scale

Leigh Ann Gale

The short sections of stems in Gale's *Winter Twigs* invite us to examine them more closely. The buds that will become next year's leaves can be seen, so too the scars left by the previous year's leaves.

Painting a themed group to create a unified composition is a useful visual device, particularly when painted to scale, as here. Usually twigs, stems and branches – the skeleton of a plant – are a secondary focus to leaves and flowers. Painting on the smoothest of hot-pressed papers, Gale used a delicate dry-brush to ensure no details were missed.

Tip Even when many plants have died back or slowed their growth during the coldest season, there is always something available as subject matter. It's useful to know that each twig is painted to scale in relation to its neighbours. This is a convention of scientific botanical illustration.

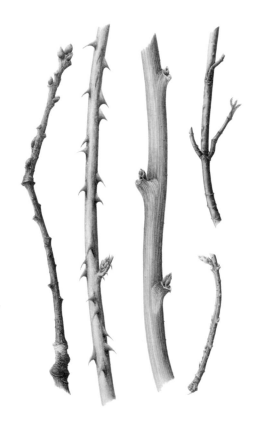

Working with a single colour

Sandra Edith

Edith's *Wild Botany* makes a fresh statement using a single colour. Rather than working to produce an exact rendition of the leaves, the artist's vision was to create a series of bold symbols with a tribal style in the pattern.

Edith has a background in printmaking, so using watercolour paint was a new venture for her. For this exercise, she concentrated on the selection and manipulation of a rich, dark-green shade alone. In exploring the 'fragility' of the medium and its transparent qualities, she particularly enjoyed the tonal variation that watercolour allowed her in capturing the essence of these chlorophyll-filled forms.

Tip If you want realistic greens and are using a commercially mixed green, don't use your paint straight from the tube; experiment by mixing it with a little of another colour. Keep a record of your outcomes.

Scaling up

Denise Ramsay

Ramsay's *Fireworks* depicts a pincushion protea, a dramatic flower prized by florists, on a white background. This showy starburst-shaped bloom is made up of tiny flowers that really do seem to mimic exploding fireworks.

To pay homage to this extraordinary plant, Ramsay scaled up – the work measures over one metre square, which is very large for a botanical watercolour. Ramsay decided the best approach for this complicated subject was to 'start small'. Working from the lower edge, she painted the flower in blocks of five to eight square cm, expanding upwards and outwards until the painting was complete.

Tip Having the subject suspended in white space helps to focus purely on the scaling up. It brings aspects of light, shape and colour to the forefront, with no distractions. Everything quietens down and a single, dramatic focus can be achieved.

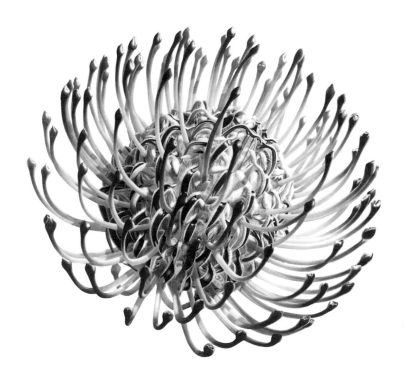

Image transfer

Iskra Johnson

Johnson's abstract painting of milkweed depicts two plants facing each other. According to the artist, each milkweed plant is in conversation with its echo, the shadow of summer and all that passed under the summer sun.

Worked on wooden panels coated with Venetian plaster, *Butterfly Weed (Aeskulap)* is a departure from more conventional approaches. The plant image began life as a photograph, altered extensively through digital drawing using masking and blending. Through a delicate image-transfer process, these were embedded into the plaster, painted and stained with inks and mica.

Tip Various techniques exist for image transfer. In this example, Johnson invested much time in preparing the panels – several stages of sanding, painting and glazing were completed before the milkweed images could be added.

83

Alla prima

Helen Ström

For *Two Lemons*, Ström has placed the fruit – with leaves intact – in a neutral white space, pulling our focus to the fruit and leaves and the shadows they cast.

The piece has been painted *alla prima*. A term mostly applied to oil painting, in the context of watercolour works *alla prima* best describes short studies, finished in one session, that capture the colours and light of the subject. In Ström's case, the piece was executed at the end of a working day, quickly, and without any pressure about success.

Tip Working *alla prima* is an effective method for honing your observational skills. This piece was painted after a long session on a work that needed a slow execution, demonstrating that the technique can also help to release energy and tension.

Complex layering

Henrik Simonsen

In this atmospheric piece, delicate blooms teeter precariously at the tops of their tall, slender stems. Worked in a single colour, the flowers become paler and less defined as they recede.

Every painting Simonsen makes begins with freehand drawing, which he works and reworks. With *Pale Blue*, he used layers of washed-off paint, charcoal, graphite and oil paint in varying degrees; the process was repeated a number of times. Simonsen rarely attempts to erase anything completely, but keeps his initial drawing – changed or worked over – as part of the finished piece.

Tip The washed-off layers of white paint make this painting feel atmospheric and suggest a layered depth. A canvas surface is robust enough to withstand the processes described. Placing a sheet of tracing paper over more delicate surfaces can similarly 'knock back' colours and tones to tint or lighten them.

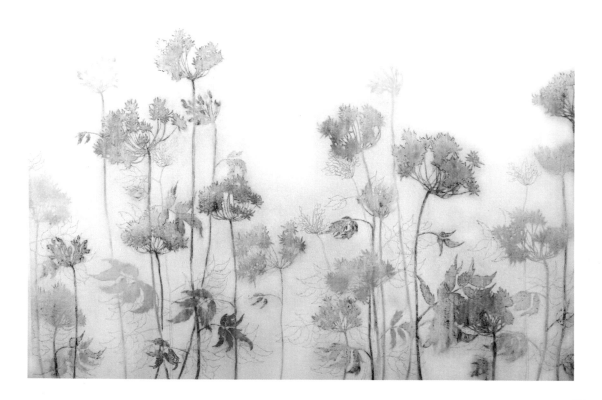

Cropped composition

Anarkali Check

Check's tightly cropped *Wilting Daffodil* examines the flower at the end of its life cycle. She has brought poignancy to the composition through isolation and use of negative space.

Drawn freehand with a fine sepia pen, there is no preparatory pencil drawing. The linework is achieved as much by looking at the subject as at the paper. The result is a sensitively handled exploratory drawing made up of carefully rendered crosshatching and short, staccato pen strokes. The splatters of orange and yellow ink remind us of how the flower once was.

Tip Before drawing in earnest, consider planning out your drawings using thumbnails – literally making a small sketch. A thumbnail can help you figure out composition, explore ideas and avoid errors before starting your 'proper' drawing.

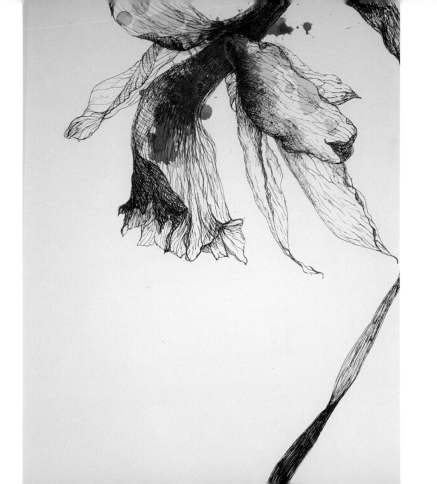

Sparing in detail

Helen Ström

Wild Flowers aims to capture the sense of a long-stemmed bunch of meadow flowers without too much specific detail.

Describing her style here as 'painting from life in a *caligraphique* way', Ström used lively, spontaneous brushstrokes to paint the impression she got looking at this bunch of wild flowers. Every artist develops their own combination of washes and brushwork. The linework of the horizontal stems could be portrayed with the wet point of a round brush or with the chisel or flat side of a flat brush. Turned at an angle, the flat brush can make thick and thin calligraphic marks similar to those of a round-ended brush.

Tip Grasses can be challenging to depict. Think about how much detail you really need to use. They are often the supporting element in a painting rather than its focal point. Characteristically, they are not a still plant. Allow your rendering to reflect that, too.

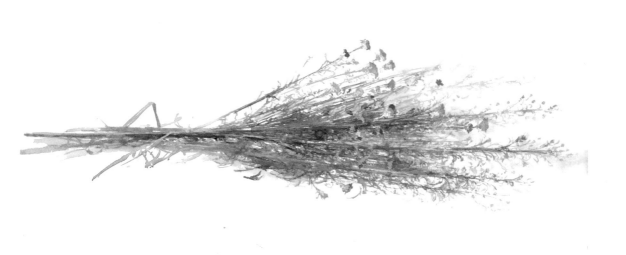

Leaf structure

Norma Gregory

January King presents a magnificent purple and green cabbage on a pale background. The artist's focus here is on accurately capturing the vegetable's dense profusion of leaves.

The leaves of plants are not arranged haphazardly, but follow precise and characteristic rules – shape, edge, stalk, veins, apex and base all have their proper places. Using a variety of techniques – wet on wet, wet on dry, small mark-making – and a carefully structured underdrawing – Gregory treats all aspects of the plant with similar weighting throughout. Every nuance of leaf – whether vein, curl, shape, texture or tone and colour shift – is carefully recorded.

Tip Consider creating drawings and paintings where leaves become the focus of your study. Set-ups might be a single leaf (see Sally Pond's *Ginkgo Leaf* on page 55) or a comparison study (see Leigh Ann Gale's *Begonia Leaves* on page 63).

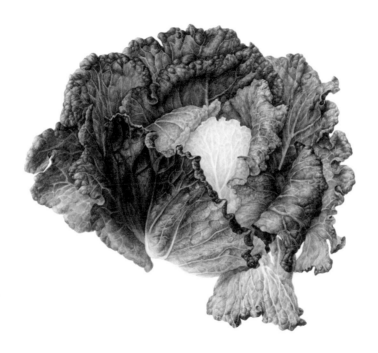

Anatomical accuracy

Gabby Malpas

Painted using watercolour, *Camellia 2* depicts two luscious pink-orange camellia flowers close up. We see just the heads of the flowers, their stems and a handful of leaves.

Malpas drew the entire piece out in pencil – right down to blemishes and veins on leaves – before she began to paint. Significant numbers of botanists and gardeners make up the artist's audience, so it's really important to her that her painting observations are anatomically correct. Having drawn everything in detail, Malpas then worked quickly with the paint, filling in areas with lots of liquid so that the images look fresh, watery and not over-laboured, as can happen if a piece is overthought.

Tip When painting in watercolour – especially if using lightweight paper or very wet washes on heavier paper – you may need to stretch your paper first. This will keep your surface flat and prevent cockling or distortion of the paper.

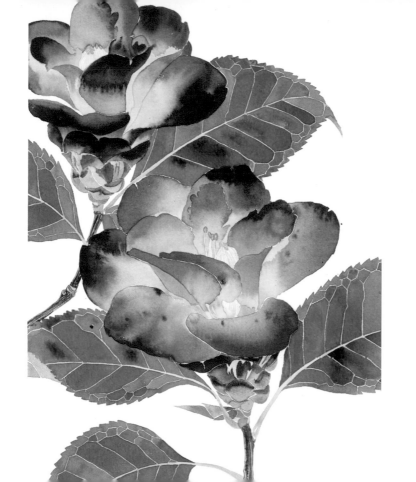

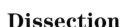
Dissection

Gesine Beermann-Kielhöfer

Beermann-Kielhöfer's horizontal dissection of beetroot and radish provides us with a view of their internal structures – specifically their concentric growth rings.

Beermann-Kielhöfer has layered tea washes on an artboard surface to achieve accurate colour outcomes in *Beetroot 'Chioggia', Beetroot 'Burpee's Golden' and Black Radish*. The name 'tea wash' refers to the fact that these are very transparent washes. In some parts of the painting as many as twenty washes have been made, either of the same colour or in diverse hues.

Tip Watercolour artboard – a 100% cotton rag paper mounted onto a stable core – eliminates the need for stretching your paper – even with multiple washes, the surface won't warp or buckle.

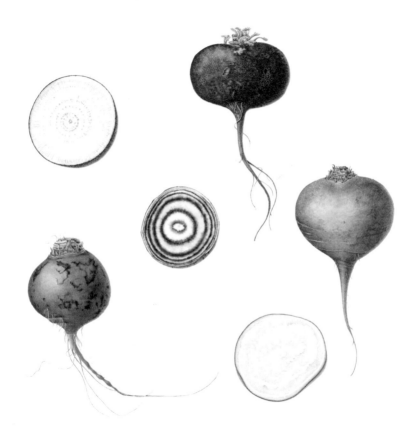

Vertical emphasis

Stephanie Law

Law's wash-and-dry-brush watercolour painting, *Echinacea*, maps the stages of a flower's development. *Echinacea* has a cone-shaped head that becomes more prominent as the flower opens and the petals begin to point downwards.

Placing the various studies at different heights ensures that the composition is a dynamic one. The vertical framing of the illustration suits the characteristics of this metre-tall plant, and its narrow format makes a compact group of the flower's maturing stages.

Tip Selecting to use a portrait or tall format like this one – or, conversely, a landscape or wide format – is an important consideration right at the start of a drawing or painting. Consider using a viewfinder – whether made from two L-shaped pieces of card held together with paperclips, or a camera.

Using white pen

Hennie Haworth

According to Haworth, *Hot Summer Garden* was inspired by a heatwave and a thirsty garden.
Set against a neutral background, this garden border is worked in a limited palette with profuse
use of white linework.

Smudges of yellow and blue pencil outlined with black and white pen define iris, lupin and cornflowers
in the garden border. The warm-toned coloured paper imbues the drawing with a sense of summer
and allows the white linework – applied with a correcting pen – to stand out. The beauty of this
unconventional medium is twofold: because it is opaque it enables you to draw over anything; and
once dry – which it does very quickly – you can draw back over it.

Tip If you choose to work with correction fluid, consider using a solvent-free,
water-based variety. It has no odour and is safe to use in schools.

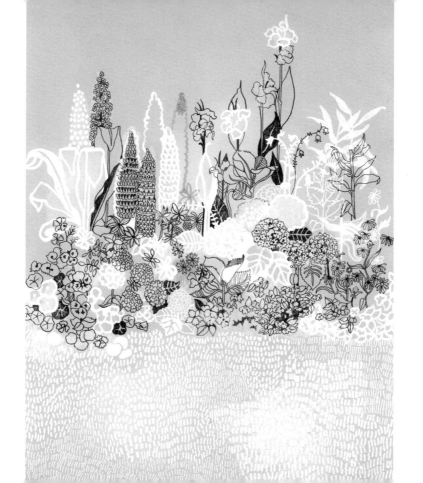

Compositional rhythm

Ku-mie Kim

Kim's *Chinese Lantern (Physalis Alkekengi)* maps the changes in the fruit of the Chinese lantern from light green to a deep orange. The degraded, papery calyx of the last lantern in the series reveals the small round fruit found inside.

By positioning the maturing Physalis like this – in two rows of five, seen from the side and from beneath – the dry-brush watercolour technique achieves a compositional rhythm, capturing and guiding the viewer's attention around the painting. Even the negative space feels measured, balanced and considered. This suits the delicate characteristics of the subject.

Tip Avoid over-cluttering your work. Compositions of small objects need much thought and careful planning. Give each component breathing space. Even a work in which botanical accuracy is excellent will be let down by a poorly thought-out composition.

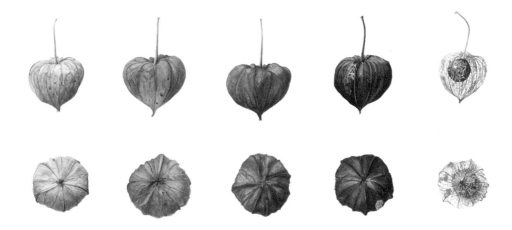

Painting on vellum

<div align="right">**Ros Franklin**</div>

Franklin's *Limone di Sorrentino* is a celebration of this important cultivar grown within a protected region on the island of Capri in southern Italy. It is painted on vellum – a surface produced from calfskin.

Franklin is drawn to intricate detail and textures, and this is particularly suited to work on vellum as it provides the smooth support needed for fine detail. The watercolour is made up of numerous layers of dry-brushwork technique using miniature brushes.

Tip Pencil work on vellum should be kept to a minimum as it is difficult to remove. Because the vellum is so thin, you have two options. Either draw the image on paper first and trace it with the brush, or paint a very pale freehand underpainting.

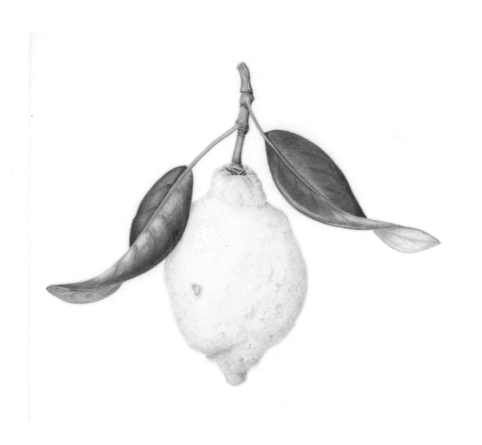

Masking areas

Eunike Nugroho

Nugroho is an illustrator of flora and fauna based in Indonesia. The leaf she has chosen to paint is from the plant *Codiaeum variegatum,* also known as croton or puring plant. She selected this leaf because it reminded her of Jackson Pollock's drip painting.

Before applying any colour, Nugroho used masking fluid to preserve space for those bright red, green and yellow markings. She then set to work on the rich dark-green tones, building them up wet on wet. The challenge here was to capture the striking colour and pattern of the leaf while at the same time depicting the sheen using transparent watercolour.

Tip Carefully observing highlights is critical if you want to create shine. Lighting a subject using directional light is really important in helping to locate them.

107

Impressionist influence

Mary Shepard

Shepard's painting of a prickly pear, *Sunstruck*, is reminiscent of the Impressionist style that emerged in France towards the end of the nineteenth century. The sensation when looking at the piece is one of the full sun striking the cacti from directly overhead. The shadows cast from the prickly pear's spines are the clue here.

Shepard's intense colours and vibrant contrasts are characteristic of the Impressionist style. Her methods are similar, too. Painting en plein air, she has used loose, rapid brushwork to capture a mass of colour and light. There is also a deliberate avoidance of hard edges, achieved by working wet on wet. The palette is significant and relies on two sets of complements: yellow and violet with green-blue, green and burnt orange. Shepard used aquarelle crayons to apply the finishing touches of colour.

Tip The paddles and flowers of the prickly pear have been painted using a variegated wash technique. Where colours meet wet on wet they produce a colour shift.

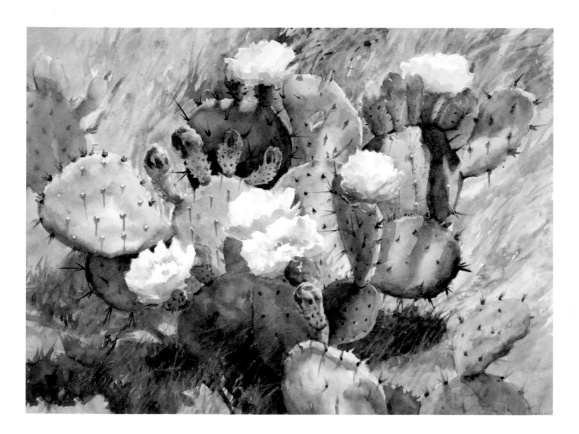

Rococo influence

Henrik Simonsen

Simonsen's *Midnight Lullaby* depicts a tranquil night-time scene, the delicate stems of garden foliage lit by the moon. A spider's web dominates the top half of the image, set against the blackness of the night beyond.

Simonsen is particularly influenced by eighteenth-century rococo interpretations of nature. This is reflected in a theatrical use of dense ornament, white, asymmetry, pastels and gold pigment. Drawing underpins this elaborate painting. Simonsen draws everything freehand, feeling that projectors and stencils take the life and strength out of the line. His working methods are organic and see him developing, adding and removing parts as he goes along.

Tip Don't be afraid to abandon a 'real' colour palette. However, do try to base your ideas on influences that you've researched in some depth. Consider keeping a specific sketchbook, notebook or online folder for this.

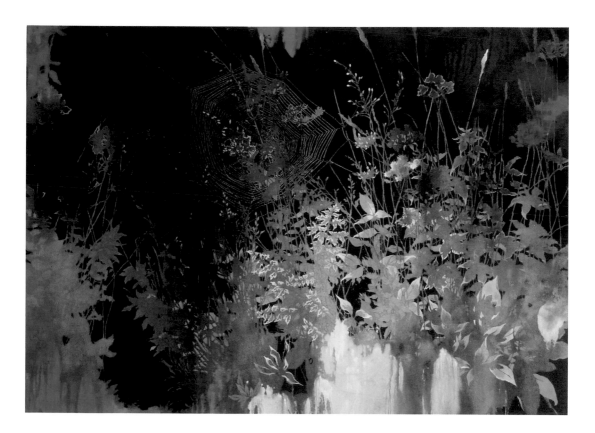

Close observation

Chris Meechan

In *Stem*, Meechan has decided to scrutinise just one part of the plant commonly known as hogweed or cow parsnip. Usually recognised by its large, white, umbrella-like flowers, here it's the segmented stem of the plant that is the focus.

Observing a specimen in a less typical way often brings new perspectives to how we identify it. Meechan has drawn the hogweed stem larger than life-size using a permanent marker pen. He's paid particular attention to the ridged stripe patterns and the way the leaf joints are formed. A blended wash of acrylic paint over the ink drawing completes the study.

Tip When layering media – here acrylic paint over ink – ensure that your media does what you want it to do. If Meechan's drawing study hadn't been made using permanent ink, the addition of the acrylic wash would have blurred his linework.

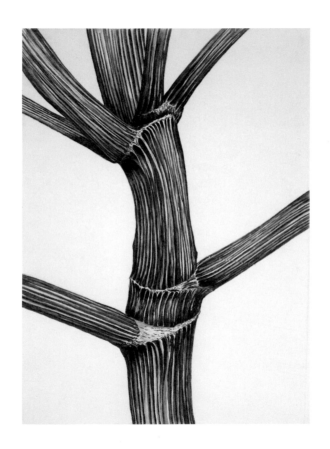

113

Retaining highlights

Gesine Beermann-Kielhöfer

Beermann-Kielhöfer's watercolour painting, *Dahlia Pinnata 'Arabian Night'*, is a well-considered composition, its richly crimson blooming sequence sitting balanced on the page.

The highlights on the inner petals of the flower were made with fine lines of masking fluid applied using a dip pen. Doing so allowed Beermann-Kielhöfer to 'reserve' areas of untouched paper, giving her much more freedom to build up wash layers and to create the beautifully deep colours of the dahlia.

Tip Try not to use brushes when working with masking fluid, as it will ruin them. Use an old brush that has been dipped in soapy water instead. A silicone-tipped colour shaper, or ruling pen, is also useful for applying masking fluid.

Using negative space

Helen Ström

In this observational piece, Ström captures what she calls the 'dancing' movement of the leaves of a wood violet plant. She has placed the plant in a transparent vase, so that its roots are also visible below the water's surface.

Wild Violets in Moleskine, a rendering of the plant in its entirety, was produced in the artist's Moleskine sketchbook. The centre stitching of the book hasn't dictated a symmetrical placement of the plant, however. Instead, the composition has been determined by using negative space. A loose graphite sketch places the geometric form of the vase slightly off centre. When adding watercolour, Ström has intentionally left the painting a little unfinished to let the viewer finish it in their mind.

Tip It may sound obvious, but don't close your sketchbook whilst your work is still wet! Make sure any wet or damp work is bone dry before opposite pages make contact with one another.

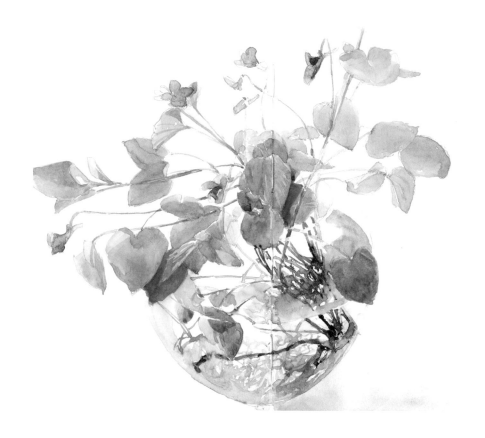

Working with India ink

Helen Gotlib

Gotlib has a background in printmaking and scientific illustration. Her drawings closely scrutinise detailed changes in plants over time. In *Sunflowers Fall*, she sought to capture the delicateness of the dry final state after vibrant life.

To create weathered atmosphere, Gotlib added and removed both wet and dry mediums. Having worked several layers of pen-drawn India ink, she applied layers of gouache. Once dry, she rubbed away areas of gouache using a scrubber brush to generate texture.

The large negative area of golden ochre to the right of the frame effectively demonstrates the outcome of manipulating the water-soluble paint – wonderfully flowing blooms of autumn colour. The sunflower with lightest petals is the result of subtractive, or rubbed away, paint.

Tip India ink – also known as Chinese ink – is completely waterproof when dry. This means that you won't lose any of the details of your preliminary drawings if you choose to work wet over dry at a later stage.

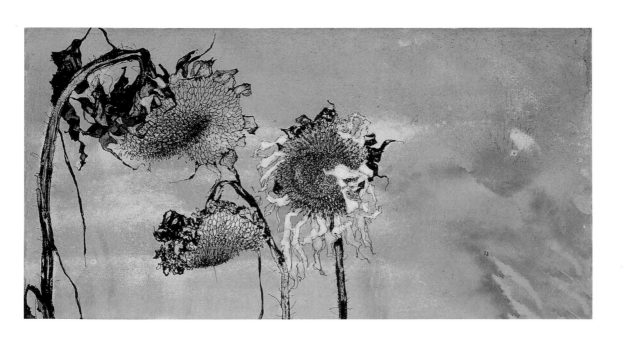

Botanical art

Julia Trickey

Trickey's larger than life *Desiccated Clematis* is one of a series of oversized flowers. It depicts two clematis flowers that are past their best, their dried and curling petals rendered in fine detail.

One of the conventions of botanical illustration is to portray plants at a 1:1 scale. Accurate measurements help botanists to distinguish plants 'in the field'. Botanical art, on the other hand, demands an accurate depiction but is often created at a much larger scale, as here. This less-restrained approach allows a botanical artist to create a 'portrait' of an individual specimen. (See Claire Pelta's portraiture on pages 18 and 178.) Techniques used in this watercolour include wet on wet, washes, dry brush and, for the stamens, masking fluid.

Tip Trickey is a botanical art tutor. She often shares her techniques online. Search for her masking-fluid technique on YouTube.

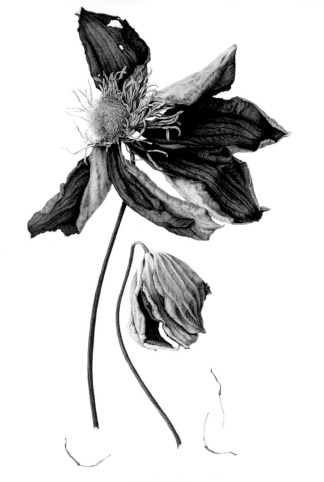

121

Building colour and texture

Hennie Haworth

Haworth's *Side of the Path* shows a densely packed flowerbed – a green microcosm in which plants and flowers jostle for light and space.

This common garden scene is typical of Haworth's work, as she is particularly drawn to everyday surroundings. Here, she has used a mixture of materials including pen, pencil, watercolour, chalk and green and red stickers to capture the wealth of hidden colour and pattern. She variously uses techniques of drawing, shading, blending, layering, painting and white-out pen.

Tip Often, Haworth's approach is to use watercolour to build up blocks of colour initially, and then to draw on top of the watercolour once it is dry.

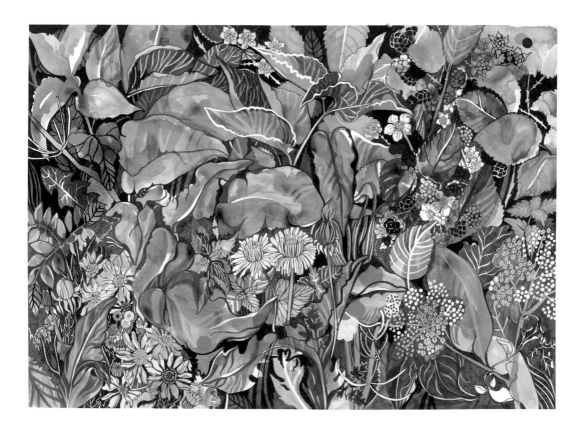

Dutch tradition

Julia Trickey

Trickey's *Tulipa 'Blumex'* honours several aspects of the Dutch tradition. Tulips were an expensive and very much sought-after flower in the 1700s. They are a mainstay of Dutch flower painting of the period.

Then, as now, beautiful and detailed paintings were a way of 'preserving' flowers beyond their natural season. Typical characteristics include the use of a distinctive black background and a flattened arrangement suffused with even light so that every part of the tulip can be admired. Watercolour and gouache washes, wet-in-wet plus dry-brush techniques have been used to depict this vividly coloured, minutely detailed and seemingly spot-lit luminous flower.

Tip A black background is not typical of contemporary botanical works. It can be achieved with gouache, or through digital means.

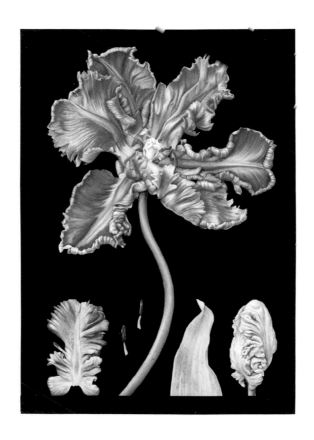

Colour relationships

Kathy Pickles

In *Mango, Peaches, Plums and Cherries*, all of the fruit chosen by Pickles belong in the red, orange, yellow part of the spectrum. She has arranged the fruits loosely on a neutral background.

Fruits make good subjects for artists. They're colourful, come in a variety of shapes and are readily available. The only contrast to the reds, oranges and yellows is the green of the cherry stalks. The narrow colour range allows the artist to depict subtle variations within and away from the red colour family. The crimson of the cherries and parts of the plums appear bluer, while parts of the mango seem slightly greener.

Tip It's highly recommended that you create your own set of colour-mixing charts – sometimes called cheat sheets. These will help you keep a clear record of your experiments, discoveries and failures!

Also: see Madeline Harper's *Red Parrot Tulip 'Rococo'* on page 37.

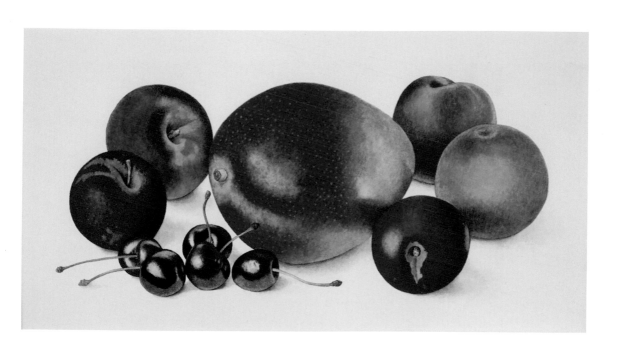

White as a colour

Katie DeGroot

Grey Birch II is one of several paintings of trees by fine artist DeGroot and depicts a close-up of two grey birch trunks side by side. The piece developed from her observation of the trees in her neighbourhood.

Atypically for watercolour work, DeGroot has applied white as a surface colour over layered washes. It suits the characteristic white peeling bark of the trees. DeGroot's advice is to work quickly and then walk away. If you push too hard, or second-guess, you run the risk of overworking the piece.

Tip A traditional watercolour technique is to use the white of the paper for highlights. If you're not a 'purist' and like a non-translucent, matt finish to parts of your paintings, use Chinese white watercolour or white gouache.

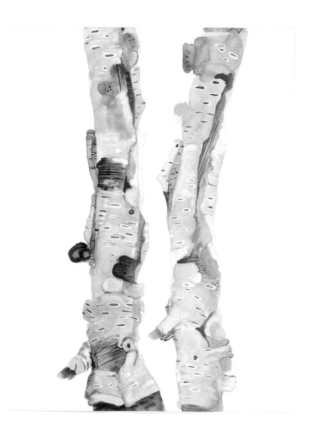

Aerial perspective

Laura Silburn

Silburn's *Primula Silver Lace* depicts a gold- and silver-edged primula. Prized by the Victorians for its attractive, multicoloured blooms, the plant was often used in 'theatre' displays. Using an aerial perspective adds depth to the picture.

In order to portray the flowers' colours accurately, Silburn used an underglaze of bright pink and added a maroon wash over the top once it had dried. Making sure the white edges of the flowers were clear and bright helped to separate each flower, but they needed shading on them, too, to stop the flowers looking flat. Dry-brushing detail with very close observation gave the picture botanical accuracy.

Tip When working with an aerial perspective, it is important to factor in the various angles of each bloom. When faced directly, these flower heads are basically circular; as they angle away, the petals at the front are foreshortened and the flower heads become elliptical in shape.

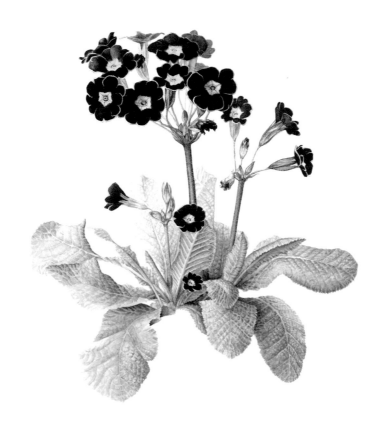

Painting true to life

Asuka Hishiki

Hishiki presents *Giant Kohlrabi – Brassica Oleracea* as if this vegetable were an individual, not a generic form. Centred within a square frame, the kohlrabi is easy to imagine as an animated face.

Hishiki worked from life and not from a photo to create a regular portrait of the kohlrabi, so as to capture its originality. This vegetable might not win a beauty contest, but its colouring, texture and subtle bumps and dents indicate that the artist – in her own words – 'faced the actual subject'. For her, a true representation is an integral part of the work.

Tip Botanical artwork is scientifically and botanically correct but not necessarily complete. As here, it places more emphasis on the beauty or appreciation of the plant.

Working to a brief

Sharon Birzer

Birzer is an artist, art tutor and natural science illustrator. Her *Bougainvillea* watercolour was prompted when she was approached by a couple who were opening a new bakery and they had a very specific idea of what they wanted for their branding.

Birzer went to the source – to observe the plant first hand. She visited local botanical gardens and made study sketches of the bougainvillea there, completing many colour mixes and samples for the client to match a colour they wanted.

Tip Designing for a client often means interpreting what you see to fit a brief. Note how the flower's stylised stamen and pistils are left white. A monochromatic scheme is also used by Natalie Ryan in her illustrative design *Banksia Leaves* on page 43.

Achieving balance

Sarah Melling

Melling's drawing is of lilies from her own garden. She usually finds odd numbers more pleasing to the eye, but here she has painted two specimens – each from a different perspective.

Although certain practices – such as that of Japanese ikebana – adhere to an odd-number tradition in order to achieve balance, this pairing works because these lilies are oddly asymmetrical. Several key elements help *Calla Lilies* achieve balance. These include the front and side views of the lilies – very much how they might be composed in a scientific botanical study; the colour-blended segueing of green into yellow-green of the stems before the drama of the bright yellow spadix, and the handling of white flowers against a white background.

Tip Some of the principles of ikebana – the importance of shape, space, line, aesthetics and balance – can be helpful in putting together your own arrangements. Learning a new viewpoint may perhaps help justify new approaches, too.

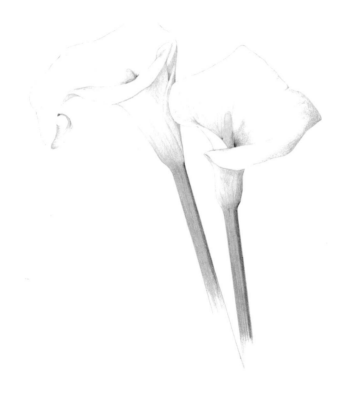

Contemporary colour

Helen Dealtry

With a loose, free style and giving the colours in nature a 'twist', *Pansies 'Emilia'* reflects Dealtry's work as a textile designer. With the negative spaces giving shape to the mass of flowers, they almost fill the frame.

Working on cold-pressed paper – robust enough to allow for multiple washes – Dealtry has used inks to achieve the vibrant contemporary colours in this piece. Working wet on wet she has made strokes and marks with a variety of brushes to achieve floods and blooms of colour. Note that you relinquish a certain amount of control when using inks, as they tend to do their own thing, but if you can resist overworking them, the results can be beautiful.

Tip Consider using dye-based inks if you want to achieve bright, intense colours like these. Note – they are not lightfast, so should be used only on pieces intended for scans or storage, rather than for exhibition.

A wider context

Daniela Dahf Henríquez

Henríquez's work caters to a market for greetings cards and giftware, hand-drawn lettering, plus editorial, fashion and whimsical narrative illustration. Her isolated, centre-of-page pot plant on a clear white background would be an ideal image for a card design.

The majority of images in this book have been drawn or painted by botanical illustrators. Their specialism of study and output is specifically of the plant world. But Henríquez's subject matter is more varied. Sometimes she draws objects like this pot plant simply to maintain a keen eye. Her style is to draw in pencil and to add pale washes of colour. The result, seen here in *Sansevieria*, is a very delicate and subtle drawing.

Tip Many illustrators keep daily sketchbooks or maintain 'personal work' portfolios to showcase the roundedness of their abilities. When clients come looking, this means that an illustrator's wider skills base is instantly accessible.

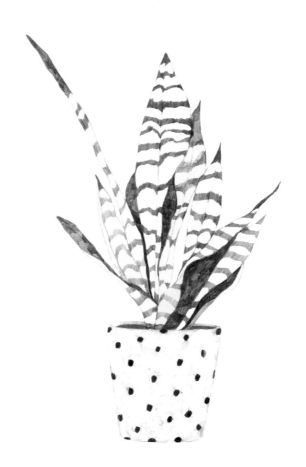

141

Working with pencil

Lâle Güralp

Güralp's *Protea and Rose Drawing* was created to grace a couple's wedding stationery. The groom was from South Africa and the bride from England, and the piece shows the couple's national flowers leaning towards one another.

Using only a HB pencil, the drawing has been built up gradually on a beautifully soft, delicate and smooth surface. It is a sensitively produced illustration. The pencil has been kept very sharp for the most part, with softer tones created using a less sharp pencil, and no smudging. As using an eraser would damage the paper's surface, the drawings have been scanned and rearranged on a white ground to tidy them up.

Tip Outside of the United States, pencils are labelled on the HB graphite scale: H = hardness, B = blackness. F is also used to indicate that the pencil sharpens to a fine point. An HB grade at the middle of the scale is equivalent to a #2 pencil using the US numbering system.

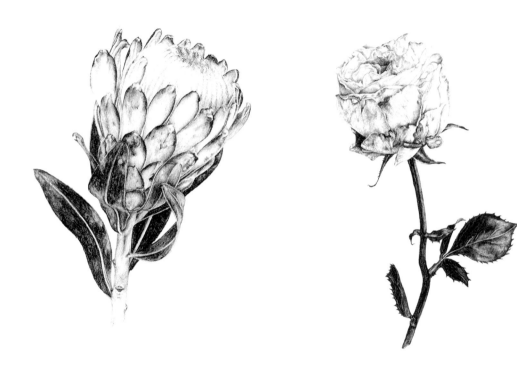

Observational study

Helen Ström

In this seemingly humble sketch study, *Pine Cone I*, Ström reveals the cone's true complexity, since the scales are arranged in a Fibonacci pattern.

Pine cones of all species are a favourite subject for Ström, who believes our interest in nature grows with the process of observing and painting. It is through her own observation of this pine cone that she has been able to render it with such detail and accuracy. The work is made using graphite pencil layered with washes of watercolour.

Tip After drawing the basic shape, count the number of diagonal rows in each direction and draw them on your outline shape. Each diamond represents a scale. Now you can carefully draw the scales in one by one.

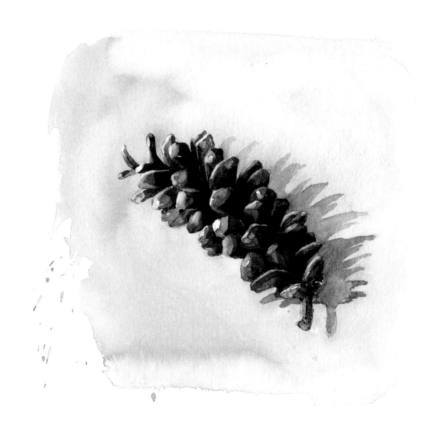

Secondary sources

Elizabeth Terhune

Garn shows a loose collection of stylised blooms that lack the detail of a botanical drawing. A fine artist, Terhune looked to floral motifs on women's clothing as a source for this piece.

By not drawing from life and using real flowering plants as her primary source, the artist has created a secondary source drawing through observing something already 'filtered' by someone else. Varying the source of your inspiration can aid in loosening your approach. The mark-making in *Garn* is experimental and expressive. Watercolour, ink and bistre are applied wet on wet.

Tip Often associated with the style of seventeenth- and eighteenth-century drawings, bistre is a brownish-yellow pigment traditionally made from the soot of beechwood, boiled and diluted with water. Bistre is transparent and often used in conjunction with pen and ink as a wash. It is waterproof and eraser-proof when dry.

Working on gesso

Kirsty O'Leary-Leeson

O'Leary-Leeson's work *In Amidst* is a pencil drawing on gesso-primed wood. The frame is filled with delicate plants in silhouette, their forms becoming less sharp to suggest distance.

Although this piece has the look of a photo or a print, it is all hand drawn using a pencil, but O'Leary-Leeson does not work on paper. She has wooden boards sprayed with gesso and sanded to give a very smooth surface onto which she draws directly using a very hard 4H pencil. Anything softer creates too much loose graphite. The images are built up with very small marks and she does not shade, but embeds each stroke within the gesso. Gesso is an unforgiving medium to work on; unless the mark is very light you cannot rub it out, so O'Leary-Leeson had to work carefully and meticulously.

Tip You can buy gesso panels ready made or prepare your own. For wooden surfaces, apply at least two to three coats, sanding each layer silky smooth with fine sandpaper once bone dry.

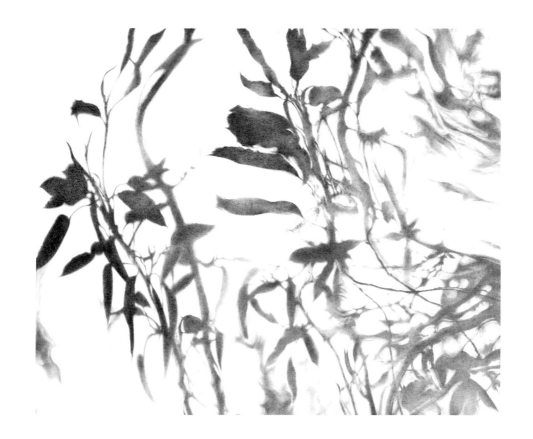

Blending and burnishing

Sarah Melling

Melling's *Haas Avocado* is a tale of two halves – the rough and the smooth. By showing both the front and back of the halved fruit, she captures the contrast between its creamy, smooth flesh and its dark, bumpy skin.

This piece is an experimental study in how to use the same media to create the illusion of these interior and exterior surfaces. Melling began with the skin. Underdrawing uses the tooth of the paper to allow flecks of white to remain and create the illusion of texture. A greater degree of blending and burnishing – effectively pushing the pigment into the tooth of a Bristol board's surface – creates the avocado's creamy centre and shiny stone.

Tip Bristol board is an uncoated paperboard; plate finish is incredibly smooth and excellent for pen and ink. Pencil, charcoal and pastel need a texture, or tooth, to adhere to the surface – vellum is best. Visit Melling's blog to read more about her process.

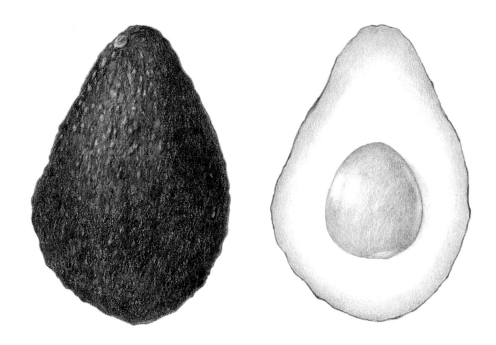

151

Properties of mixed media

Chris Meechan

Meechan's keen eye for the underappreciated is evident in *Convolvulus* (see also pages 112 and 170). In this study, the plant has wound itself around a bamboo cane placed diagonally and dramatically across the composition.

The work is a celebration of things we might see during the winter months – a time when many plants have died and dried leaves and stem structures come into their own. The cane has been painted in watercolour, whilst the dry, brown leaves have been rendered in acrylic and permanent black marker pen. A mixed media approach brings a range of tones into play. Utilising black adds to the stark contrast of this winter observation.

Tip When using mixed media, ensure that you understand its properties. The transparent nature of watercolour meant that the cane had to be painted first. The opaque nature of both acrylic and marker pen meant they could cover it – but not vice versa.

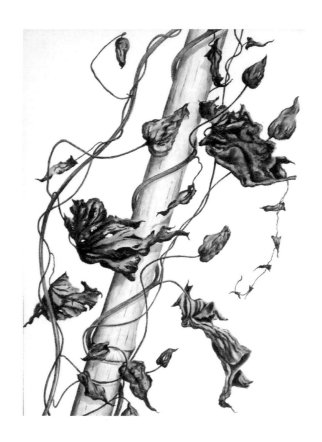

Working on black paper

Helen Read

Read took a reference photo for *The Edge of Shadow*. There is a great play of light and shadow, as the photo was taken just after a rain shower. The sun shone brightly, casting interesting shadows.

Getting bright colours to work on a black background, as Read has chosen to do here, can be challenging, as the black of the paper shows through and influences additional layers of colour. Avoid the temptation to use a lot of pressure and burnishing – build the pencil layers using light pressure. If you flatten the tooth of the paper too much you won't be able to build up colour on top effectively.

Tip Don't hesitate to capture the moment if a particular cast of light, colour, texture or compositional suggestion presents itself. Just remember that working from a photograph is not the same as working from life – there is no light play, perspective is flattened and colours may be distorted.

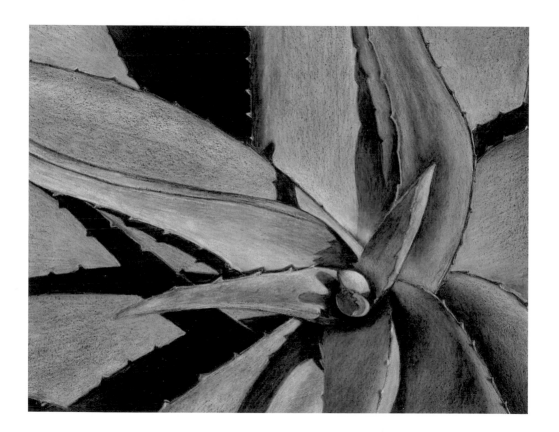

Careful editing

Lisa Goesling

The scratchboard drawing *Unfolding* was inspired by an Eremurus or foxtail lily in mid-bloom. The work explores how each separate flower is part of the whole and Goesling has purposefully left parts unfinished to emphasise this.

This large piece (almost one metre wide) presented the artist with a challenge: anything left out should be equally as important as everything that is put in. Editing is crucial, as it gives the eye a place to rest before diving back into the details. Goesling has drawn white outlines followed by intensely observed tonal renderings – created by carefully scratching the India ink surface away. Finally, she has added colour with acrylic inks to pick out three full blooms and the flower tip.

Tip If you want to add colour to a scratchboard acrylic drawing, inks are ideal – they are transparent and waterproof. Once the colour is in, go back and scratch out the highlights as necessary.

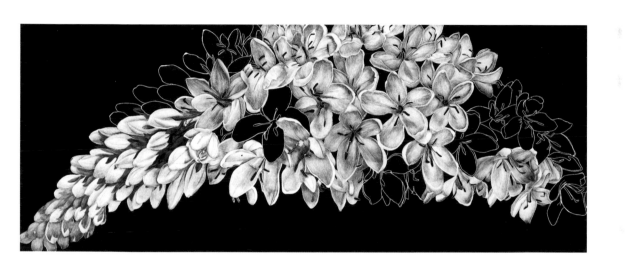

Crosshatching

Helen Ström

These tamarind seedpods make an ideal subject. They are simple yet sculptural in form. Ström is often attracted to very simple subjects and came across these examples whilst visiting Mauritius.

Ström's habit is always to be on the lookout for things she can draw from life – a good approach to embrace. The trick is to be prepared – a sketchbook plus pen or pencil is often enough. In *Mauritius Studies*, the earthy toned sepia pen complements the creamy acid-free paper of a Moleskine sketchbook. By suggesting a tonal shift from light to dark and including shadows beneath them, the tamarind pods seem to become three dimensional.

Tip Unlike a pencil, a pen doesn't allow variations in tone by altering pressure. Shading is achieved by utilising a crosshatching technique – the denser the overlay of line, the darker the tone.

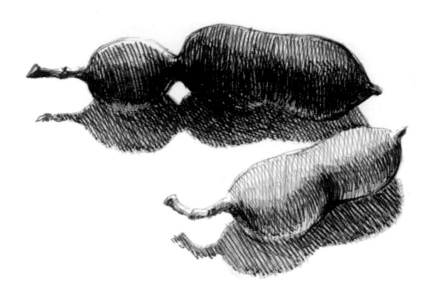

159

Detailed study

Fiona Wheeler

This watercolour and graphite work, *Ornamental Gourd*, took several months to complete. It is a study that captures, in fine detail, the subject's knobbly green and yellow warty surface.

Wheeler began with a preparatory sketch and colour study, which she refined and transferred with tracing paper onto hot-pressed watercolour paper. She rarely uses masking fluid, but as the surface of this gourd was covered with tiny white speckles, masking them was the best option. Several thin washes of watercolour were applied. In the later stages of painting, dry brush was used to add detail.

Tip If you know you want to take your time and make as detailed a study as this, pumpkins, squash and gourds are ideal subjects. If you've grown your own, cure them first to prevent rot. Once dry, buff up the exterior and you're ready to draw and paint. In a well-ventilated room, your subject should last two to three months.

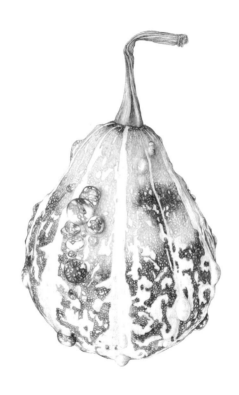

Anatomy of a plant

Marianne Grundy

Some objects naturally invite closer inspection. With *Artichoke*, Grundy demonstrates why. She's presented us with the flower bud cut through lengthways to expose its various layers, next to another beginning to flower.

This study is about first establishing forms and patterns, dealing with them a section at a time, maintaining highlights on the cut-through stem, heart and choke – the fuzzy, hairy section above the heart – with the lightest of washes, and then strengthening tones and textures. Washes over pencil work deepen the tones, pick out details and strengthen the image.

Areas of highest contrast are the biggest focus in a work. Here, the dark purple, almost black, centre next to the palest warm yellow takes that focus, literally, to the heart of this illustration.

Tip In order to draw the minute and subtle details of plant structures, it is crucial to work with a light touch and a sharp pencil point. Anything harder than 2H should be used with great care, as its hard point may dig into the paper.

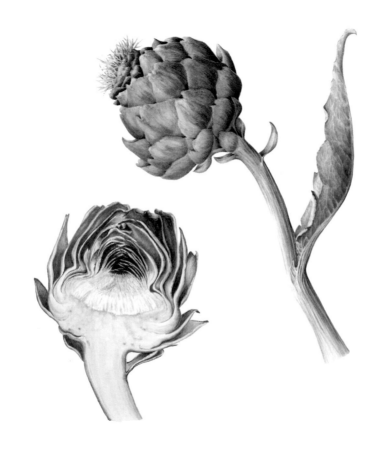

163

Using dip pen

Rachel Lockridge

Lockridge's line-and-wash drawing of two sunflowers is a contour drawing – that is, a drawing that describes the outline of the object. In this case, the flowers are set on an ink-wash background.

Sunflowers was created using a dip pen. When drawing from life, you should look more at your subject than your drawing. It's clear that Lockridge has scrutinised her subject closely. She began with a detailed contour study in ink and then used various grades of ink wash of the same colour. Her mark-making incorporates flowing lines for petals and stalk, and squiggling zigzags for the flower centre. There is an observational liveliness to this drawing.

Tip Dip-pen drawings are best executed on a smooth hot-pressed paper – the pen action is smoother and the nib less likely to snag. However, Lockridge has used a cold-pressed paper. The texture is apparent in the ink-wash background, which enhances the drawing's appearance.

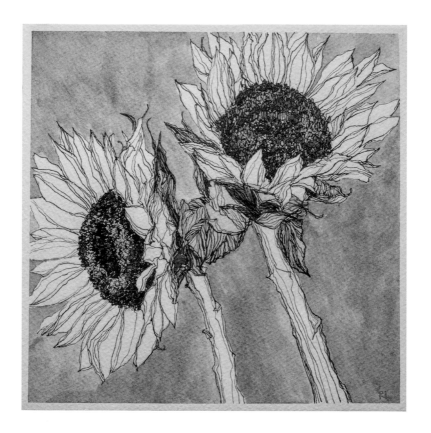

Scratchboard as a medium

Lisa Goesling

In *Pussy Willows*, the scratchboard medium really suits Goesling's detailed rendering of three pussy willow twigs, depicted running horizontally across the surface. The white-out-of-black, or subtractive, method perfectly suits the creation of the tufted white hairs of the catkins.

Scratchboard is hardboard coated with white kaolin clay, which in turn is covered with black India ink. Sharp tools are used to scratch, scrape or 'etch' through the black ink and reveal the white clay underneath. Goesling used an X-Acto knife to draw the feathery pussy willow catkins, creating a hyper-detailed image. The process is a slow one; she often needed a magnifying glass to work some of the finer details.

Tip A variety of effects can be achieved using various abrasive tools. Scalpel blades are popular because the point can be used for stippling, crosshatching and fine work, whilst the edge can be used to create broader lines or larger white areas.

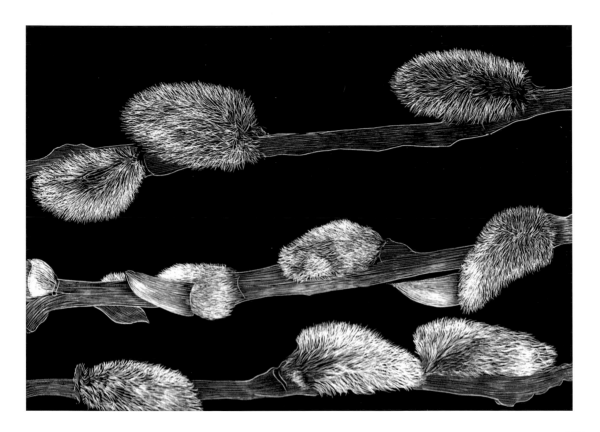

Sanguine tones

Brian Griffiths

We usually see these winged seeds or sycamore keys as 'helicopters' spiralling down to land around us. Griffiths' study is of the seeds as they would be whilst still attached to the tree.

Sycamore Keys uses the highest quality sanguine coloured pencil and hot-pressed paper. The pencil colour is oil- rather than wax-based so lays down creamily on this smooth, acid-free paper. The lines of the veins were made by first inscribing a fine indentation into the paper with a metal stylus then lightly colouring over the top.

Tip Note that the earth tones of sanguine and sepia are very similar. Sanguine – also known as red chalk – is a reddish-brown or deep-rust colour, whilst sepia is yellowish-brown or burnt umber. Both are available in wood-cased pencils and as sticks. In the latter form they can be used more like charcoal.

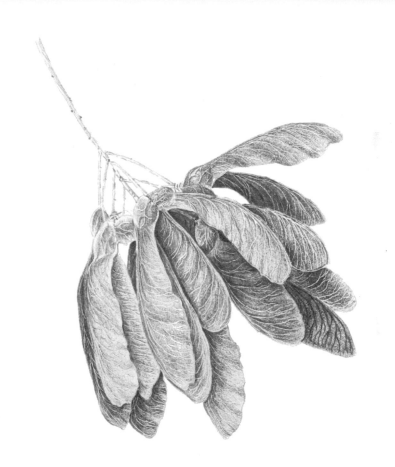

169

Plant character

Chris Meechan

Nigella damascena, or love-in-a-mist, is a popular and easy-to-grow plant most commonly known for its sky-blue flower followed by a bulbous seedpod. In this piece, Meechan has painted three of these seedpods in a row.

Working in watercolour and acrylic, Meechan has painted these seedpods with the feathery bracts that remain after the pods have dried. Painting a group, rather than a lone seedpod, makes sense. They reflect the plant's growing pattern – a mass of flowers usually grown from a scattered handful of seeds. *Love in the Mist* depicts a green, newly formed pod and two brown seedpods, reminding us of the plant's alternate name, 'devil-in-a-bush'.

Tip Any plant that forms dried, decorative seedpods is a perfect subject, as it doesn't need watering, won't wilt and will retain its shape even if you take your time painting or drawing.

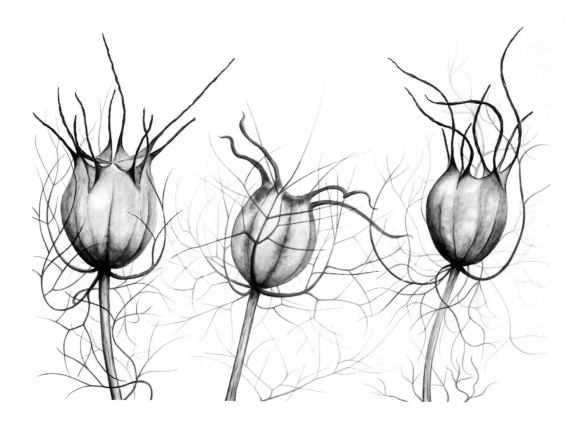

Inflorescence

Robyn Graham

Banksia Aemula is Graham's rendition of the characteristic flower spike of the Banksia shrub that is native to Australia. This 'inflorescence' consists of several thousand small florets massed together in a single spike, packed in spiralling vertical lines around the axis. The plant's serrated leaves are another appealing feature carefully observed.

There are many different types of inflorescences. Getting the flowering 'scheme' right is crucial. These details are fundamental to creating a good botanical work. The Banksia is a raceme inflorescence – the exact number of florets is indeterminate. Here, Graham has carefully observed the myriad buds as highlights reserved in the washes of watercolour. Fine brushwork and pen define them further.

Tip Each species has its own shape of inflorescence. That of the Banksia is complex. Use photographs and the actual flowers to work from if need be – accurate observation is key. See also Helen Ström's *Pine Cone I* on page 144.

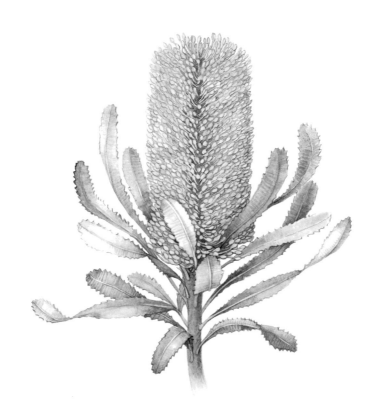

Using design software

Michelle Li Bothe

Bothe's *Tropical Tendencies* is named after her childhood in Hawaii. An arrangement of tropical leaves and flowers, the design evokes a lot of nostalgia for the artist. She has used unusual and unexpected colours, while maintaining a vintage feel to the image.

The subtle texture that overlays the piece suggests looking through a screen door, an effect achieved by combining watercolour and virtual media. Bothe started with digital sketches on a tablet, which she cleaned up in Illustrator. After that, she used Photoshop to create the composition and started playing with colour. Finally, she add watercolour textures that have been scanned in, and tweaked the hues and saturation to get the finished look.

Tip If you're scaling something up it can lose its quality very quickly. Adobe Illustrator is a vector program. Use it for anything that may need to be printed or displayed at different sizes.

Planning for design

Kat Spencer

One of a series of preliminary fine-line ink-pen drawings, *Fine Lines; Petunia* is a work Spencer created for her graduate art and design portfolio. The piece shows three petunia flowers in considerable detail, with the largest in the centre.

Keeping things simple like this – forgoing colour and producing outline-only petunias – means that Spencer could map out the form and make decisions about how things were going to fit together without colour confusing the issue. She added colour later, using Adobe Illustrator and Photoshop to produce her final designs.

Tip With colours that range from dazzling white to an almost black purple, and striking colour combinations and petal markings – stripes, stars, dark centres, bright edges – petunias are a reliable source of design inspiration.

Geometrical composition

Claire Pelta

The subject of *Passion Flower – Pink on Steel Blue* is placed centre stage, as in a portrait. It dominates and fills the painting's square format. Although botanical in style, it pushes the boundaries of botanical art, as it is on a larger-than-life scale.

Executed using oil on canvas, Pelta's work on this large painting – measuring 50 x 50 cm – began as a detailed pencil drawing. The corona filaments that circle the larger central stamens are intricate and were very demanding to paint. The flower petals and corona form diminishing concentric circles and lead the eye to the centre of the image, where the stamens form a triangle.

Tip Compare this passion flower on a coloured background with the more traditional one on white, *Flight of Passion*, by Denise Ramsay, on page 25.

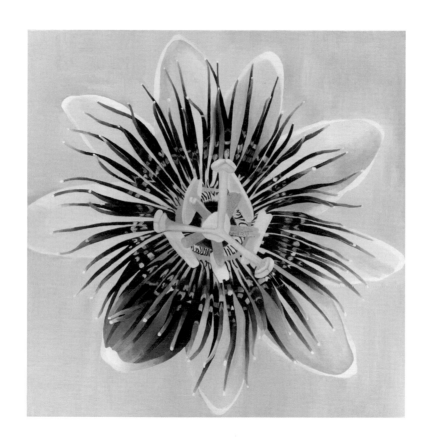

Brushwork

Mary-Clare Cornwallis

Cornwallis picked this bunch of *Nigella* from her own kitchen garden. It is a favourite plant for scattering seed wherever there is a gap in a flower border, and it has a habit of self-sowing, too. The informality of its growth is reflected in the loose flowing style of her brushwork in this watercolour sketch.

Although the artist has moved away from precise botanical accuracy, this piece still uses close observational skills. The upright stems, with their feathery bracts, are painted with the tip of the brush. They are painted freehand – there is no pre-drawing. The darker, fuller flowers utilise a different brush technique – laying the brush on its side, using the length of the bristles to lay down bigger, more solid shapes.

Tip Watercolour brushes are available in various shapes – round, pointed, long- or short-haired and miniatures, for instance. Before buying lots of brushes, experiment with a pointed round brush. You'll be surprised how much you can achieve with it.

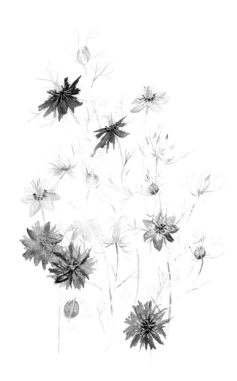

Horizontal emphasis

Helen Ström

This painting is not about intricate detail; it's about the simple, ordinary and everyday. Although one of Ström's quicker works, *Pink Turnips* presents a sophisticated observational study of the vegetable awaiting preparation. The grey puddle of shadow beneath the turnips is an important anchor point.

The globular root has been sketched out in graphite pencil before painting. The wispy, linear taproots and the green turnip tops are rendered without guidelines. The pinks are delicate – paler where the roots were below ground, slightly more purple where they protruded above. The leaves are painted loosely, the wash layers disappearing to nothing at some leaf tips. Notice how the grey shadow contains subtle hints of the pinks and greens.

Tip Many of the paintings in this book have a vertical emphasis. Consider horizontal compositions like this one as well. Fruits and vegetables sitting on a kitchen table, waiting to be prepped for meals, are ideal. Look at the rhubarb on page 33.

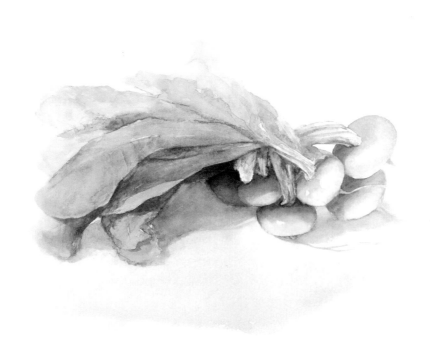

183

Digital manipulation

<div align="right">**Justin Garner**</div>

In *Gone to Seed*, a photo of a common daisy has been transformed in Photoshop by the removal of almost all of the green.

Garner is a photographer who is interested in stretching the parameters of how his images can be defined. He uses digital tools to manipulate his photographs and create outcomes that seem more painted or drawn than they are. Here, we see a predominantly red, blue and mauve flower, where layering and brush tools were used to soften and blend edges and the background to produce a painterly finish.

Tip Consider experimenting with your plant photos using phone/tablet apps. Many of the presets can be poor facsimiles of the real thing, but with experimentation and discernment you will be able to create some excellent digital drawings and paintings.

Selecting a viewpoint

Mary-Clare Cornwallis

The beauty of deciding on a quicker study, especially if it is in a pot, is that you can easily rotate the pot until you find a satisfying viewpoint. Here, Cornwallis' *Agapanthus Head* focuses on one flower – an umbel – atop a long, erect stem.

The artist is revisiting a subject she has painted several times before, this time as a quick sketch. A preliminary pencil sketch and layered watercolour washes have captured the blue umbel. Unusually, but effectively, a graphic pen has been used for the individual delicate stalks of the buds.

Tip The agapanthus may appear complicated but a handy hint is to study the negative shapes as well as the bud forms.

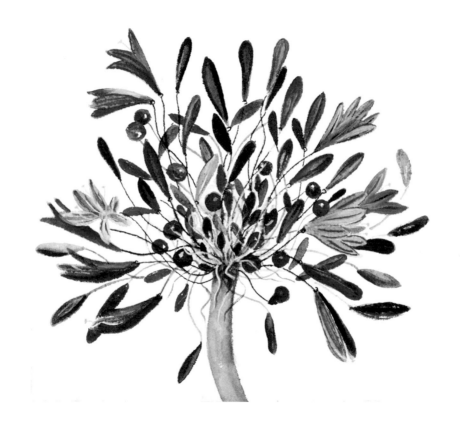

187

Acute observation

Gabby Malpas

Malpas' pencil and watercolour painting is of a eucalyptus sprig plucked from a tree in the bush on a road trip. Members of this genus dominate the tree flora of Australia. *Eucalyptus* is not a study where the specimen is tidied up; it is presented to us with all its blemishes.

The brown spots, nicks and imperfections on the leaves make this observation all the more perfect. Malpas' degree of observation is acute. A careful pencil rendering on unstretched paper has determined the position and form of the twig. Thereafter, paint is applied wet on dry. Colour mixing and application is scrutinised with the same attention to detail.

Tip A subtle pencil outline can determine where to place watercolour washes. Here, paint applied wet on dry on unstretched paper has used these guidelines. Note that there is no hint of the pencil. Once completely dry, any pencil has been erased.

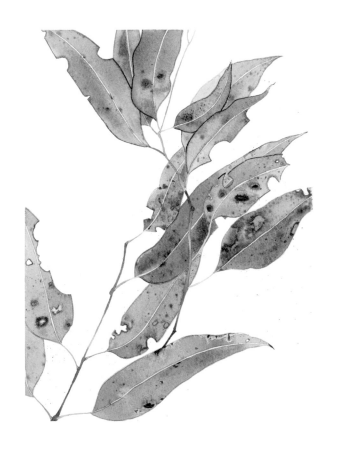

189

Wet and dry

Helen Gotlib

Spring Summer Dahlias combines wet and dry media to great effect. Gotlib has drawn the flowers off-centre on tan paper, adding a striking blue-into-green background.

Initially working from life to capture the essence of the subject, Gotlib continued by working the piece independently of the model using a variety of unconventional techniques. Having first drawn the dahlias using conté crayon, the artist applied liquid acrylic wet on wet to form the blue-into-green background. When dry, she layered in the details of the flower with gouache. The finer details were added using a final layer of conté crayon drawing.

Tip It is possible to dilute acrylic paint in water, but if you want to use acrylic in a more fluid way, liquid or fluid acrylics are recommended. Their pigment colours are more intense and, when dry, they are more stable. They're good for a range of techniques, including brushing, staining and spraying.

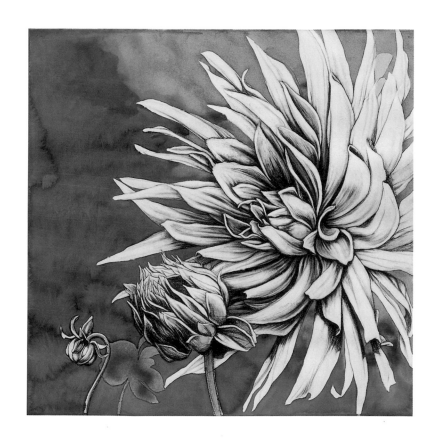

Composite presentation

Jan van der Kamp

The horizontal emphasis of van der Kamp's arrangement of irises suits the grouping, aptly named *Iris Family*. This way of presenting botanical illustrations is known as a composite presentation.

This useful compositional device allows you to present studies of component parts of a single plant, or as here, a collection of plants with a particular relationship to one another in a single frame. There are some rules. Everything should be measured so that the elements are in proportion to one another, and a composite should look attractive. The arrangement of the elements can be a complex design challenge; van der Kamp has used her experience as a flower-arranging tutor to great effect.

Tip A good way to design a composite is to draw each component separately on tracing paper, moving the parts around until you locate a composition that pleases you. Scanning your paintings or drawings and arranging them digitally would work well, too.

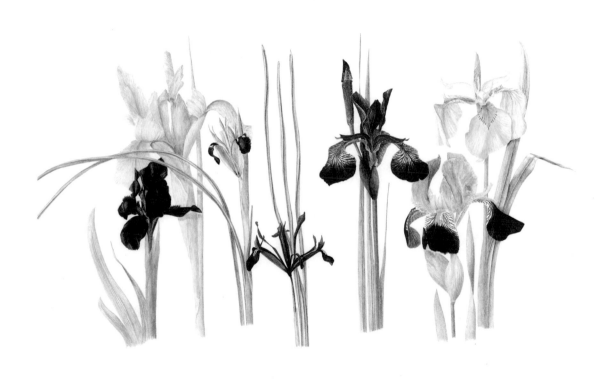

Botanical
fundamentals

Helen Read:
The Edge of Shadow

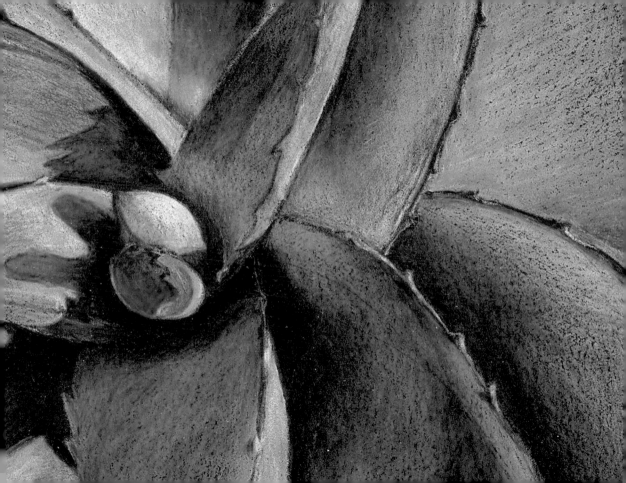

Materials

Graphite pencil lead is made of a mixture of graphite and clay. The balance of these ingredients determines its hardness or softness. The grade you select will affect your drawings' outcome. Aim to have a variety of graphite pencils, e.g. 2H (hard) for detailed drawing, HB (medium) for tracing and preparatory sketches, and 3B for rich, dark shadows.

Consider a **mechanical/propelling pencil**. These have a replaceable and extendable lead. No sharpening required.

There are several good brands of **colour pencils** to choose from. Unlike graphite pencils their 'leads' are wax or oil based. Those with a high wax content are well suited to burnishing.

Colourless **blender and burnishing pencils** help mix, smooth, soften and 'polish' coloured pencil drawings.

Paper stumps and tortillions – short rolls of tightly wound paper – are good for precision blending and softening of pencil or pastel.

The minute details of botanical drawing demand a sharp pencil point. Use electric, battery or handheld **sharpeners**. Graphite pencils can be sharpened to a very thin point. Coloured pencils, which have softer leads, are sharpened to a shorter and blunter point.

Some might prefer using a **scalpel** to hand shave off the wooden casing to get a particularly long and fine point. When your pencil gets too short to hold comfortably, use a **pencil extender**.

2H or harder will hold a good point for a good while before needing resharpening. Use hard pencils with care – too much pressure and they can dig in, leaving an unsightly dent in the paper.

Good **erasers** should lift unwanted drawing marks easily with no damage to the paper surface, leaving a minimum of residual mess. A kneadable eraser is the gentlest. A plastic or vinyl eraser is suitable, too. Precision or electric erasers are useful for detailed work.

Ink is often used to strengthen the line of a pencil drawing, making an illustration clearer, and ready for reproduction or display. Use waterproof India ink by itself or in combination with other wet media. Once dry it is permanent and won't bleed, however many washes you do over it.

Water-soluble inks are available in a wide range of bright, mixable colours. They can be used with dip pens and brushes. Lightfast pigment-based inks are best for work you intend to exhibit. Dye-based inks are not lightfast. They are best used for work you intend to scan or store.

Technical drawing pens give an even, unchanging line. **A dip pen** is more sensitive to drawing pressure, producing a variety of line widths.

Above: *Sycamore Keys*, Brian Griffiths

Transparent **watercolour paint** is available in two forms: as pans (solid cakes of pigment) or in tubes. Typically they are used to layer translucent colour washes on a white paper base, which combine with previous washes and with the paper beneath them, rather than fully concealing either. Used correctly, your paintings should retain a luminosity. Watercolours are available in different grades: professional/artist quality or extra fine, and less expensive student grade. The more expensive versions contain better pigment that will fade less over time.

If you're new to botanical painting, your basic watercolour range should include one warm and one cool shade of each colour you will commonly need. This might be: lemon yellow/cadmium yellow, cadmium red/alizarin crimson, cerulean blue/ultramarine blue, raw sienna/burnt umber and Payne's grey. Occasionally, Chinese white may be used – though not for 'corrections' on competition pieces.

Also consider **masking fluid** – a latex-rubber fluid applied to reserve small areas of white watercolour paper or already dry washes. Apply it with a mapping pen or colour shaper. It works best on hot-pressed paper.

Acrylic paint can be used as an opaque medium or watered down and used like transparent watercolour on canvas as well as paper. Once dry it can't be reactivated with water – however, this makes it perfect for applying layers that won't be affected by the application of later washes.

A selection of good quality **watercolour brushes** is a vital purchase. A basic range might include: round or pointed brushes for washes; half riggers for longer, flowing lines; a miniature, or spotter brush for fine detail work, especially dry-brush techniques, and vellum work; and flats for large areas of wash and lifting. Natural hair is best. Sable and synthetic mixtures are a reasonable alternative. You may wish to use 100% synthetic brushes

for acrylic work. Whichever brush you use, it should hold a good amount of paint, release it gradually and make a consistent mark.

Palettes are usually plastic or ceramic. An old plate will do. Choose one with a wide rim so you have plenty of room to squeeze out your paint. Always use a white palette in order to gauge the colour of the paint accurately.

Botanical drawing **accessories** that you may find useful include: masking tape, bulldog clips, measuring dividers, a small ruler and **optical aids** such as a handheld magnifying glass, a magnifier on a flexible arm and a flexible desk lamp.

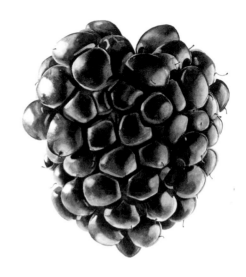

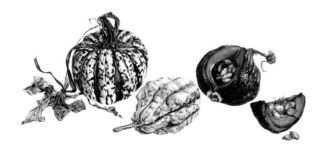

Above: *Bramble*, Victoria Braithwaite
Left: *3 Squashes*, Clare McGhee

Most fine botanical work is done on white, smooth or **hot-pressed paper**, so as to reflect light back through the thin layers of paint. Your paper needs to be suitable for water-based media, from the wettest wash to delicate dry brushwork or ink and pencil detail. The wetter the technique, the thicker the paper needs to be: 300gsm is good for light washes – anything lighter will buckle. Use 640gsm if applying a background wash. Consider stretching your paper, whatever its weight, if you think it may distort. The ground for final artwork should be of archival quality, or acid-free.

Cold-pressed, also called NOT, paper has a surface texture and is perfect for traditional watercolour effects such as granulation. **Cartridge paper** sketchpads are practical and portable. Choose one with a rigid protective cover back and front.

Tracing paper, graphite transfer paper and layout paper can all be used for planning and transferring compositions. **Bristol board** has a smooth, shiny and white surface ideal for fine detailed work, especially ink. **Vellum** was historically used for botanical painting, and is made from calfskin.

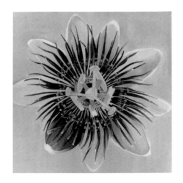

Above: *Passion Flower – Pink on Steel Blue*, Claire Pelta

Digital

Cameras, tablets and camera phones are useful for planning botanical works. They aid compositional play – allowing experimentation with framing and multiple-angle shots. They're great for taking reference shots when you don't have time to sketch, and for capturing the fragility of some specimens whilst working from them. Photos can be printed out or, if you're using a tablet, propped up in your working area. Excellent screen resolution means you can zoom in to see details more clearly. Switching to black and white or monochrome mode means you can more easily study tone.

Workspace

Most of the works in this book are typical of botanical work – small-scale and detailed. They are time consuming and require long periods of concentration. Comfort is essential. The use of a **desk easel** or **drawing board** propped at a slight angle on some books is a better working surface than flat on a table. Your chair should be the right height relative to the desk. If you are right-handed, the main source of light should come from the left (vice versa if you're left-handed) – so you don't cast a shadow over your work. A diffused north light or shaded window is best – sun glare off white paper is best avoided. You'll be concentrating on close work. Once in a while give your eyes a rest – focus on something out of the window some distance away. When you don't have sufficient natural daylight, or want a constant light where shadows aren't going to change, use a **flexible lamp** directed exactly where you want light.

Further resources

Books

Brown, P. (2018) *Botanical Drawing: A Step-By-Step Guide to Drawing Flowers, Vegetables, Fruit and Other Plant Life*, Search Press Ltd.

Guest, C. (2001) *Painting Flowers in Watercolour: A Naturalistic Approach*, A & C Black Publishers Ltd.

King, C. (2015) *The Kew Book of Botanical Illustration*, Search Press Ltd.

Starcke King, B. (2004) *Botanical Art Techniques: Painting and Drawing Flowers and Plants*, David & Charles.

Martin, R. & Thurstan, M. (2008) *Botanical Illustration Course with the Eden Project*, Anova.

Valerie Oxley, V. (2008) *Botanical Illustration*, The Crowood Press Ltd.

Parkinson, R. (2016) *The Botanical Art Files: Narratives: Volume 2*, The Botanical Press.

Phaidon Editors (2016) *Plant: Exploring the Botanical World*, Phaidon Press.

Ravet-Haevermans, A. (2009) *The Art of Botanical Drawing*, A & C Black Publishers Ltd.

Sanders, R. (2016) *Flowers: A Celebration of Botanical Art*, Batsford Ltd.

Sherwood, S. & Rix, M. (2018) *Treasures of Botanical Art*, Kew Publishing.

Simblet, S. (2010) *Botany for the Artist*, Dorling Kindersley.

Stevens, M. (2015) *The Art of Botanical Painting*, Harper Thorsons.

Swan, A. (2010) *Botanical Painting with Coloured Pencils*, Collins.

Vize, S. (2016) *Botanical Drawing using Graphite and Coloured Pencils*, The Crowood Press Ltd.

West, K. (1996) *How to Draw Plants: the Techniques of Botanical Illustration*, Timber Press.

Online

American Society of Botanical Artists
www.asba-art.org

Biodiversity Heritage Library
www.flickr.com/photos/biodivlibrary/albums

Botanical Art and Artists
www.botanicalartandartists.com

Botanical Art Society of Australia
www.botanicalartsocietyaustralia.com

Botanical Art Worldwide
www.botanicalartworldwide.info

Helen Birch, drawdrawdraw
www.pinterest.co.uk/drawdrawdraw/botanical-art/

The Japanese Association of Botanical Illustration
https://www.art-hana.com/english/

Katherine Tyrrell
www.pastelsandpencils.com/flowers.html

Sarah Melling
sarahmelling.blogspot.com/2015/03/papayas-pencils.html

The Society of Botanical Artists
www.soc-botanical-artists.org

Dutch Society of Botanical Artists
www.botanischkunstenaarsnederland.nl

La Société Française d'Illustration Botanique
www.sfib.fr

Artist index

Index

Acknowledgements

I am enormously grateful to all of the artists and illustrators who have so kindly allowed me to include their botanical drawings and paintings in this book, and to all at Bright Press Publishing, especially to Jo Turner for pulling things together.

Special thanks to Dina for sharing her knowledge of plants and flowers.

This book is dedicated to my grandmother Helen Cooper for providing me with such wonderful childhood garden memories: Lamb's-ear *Stachys byzantina*, Ox-eye daisy *Leucanthemum vulgare*, Honesty *Lunaria annua*.